Great Masterpieces
OF THE WORLD

Irene Korn

NEW LINE BOOKS

For Sandra Korn Labbee, a true masterpiece of a sister.

Fax: (888) 719-7723
e-mail: info@newlinebooks.com

Printed and bound in Singapore

ISBN 1-59764-122-7

Visit us on the web!
www.newlinebooks.com

Author: Irene Korn

Publisher: Robert M. Tod

Editorial Director: Elizabeth Loonan

Book Designer: Mark Weinberg

Senior Editor: Cynthia Sternau

Project Editor: Ann Kirby

Photo Editor: Edward Douglas

Picture Researchers: Meiers Tambeau, Laura Wyss

Production Coordinator: Jay Weiser

Desktop Associate: Paul Kachur

Typesetting: Command-O Design

CONTENTS

THROUGH THE AGES

The question of what exactly denotes a "masterpiece" might well be one of the most hotly debated issues in the world of art today.

Should the sculpture that epitomizes the spirit of a time, like Michelangelo's *David*, always be considered a masterpiece? Is a painting like Picasso's *Les Desmoiselles d'Avignon*, for example, which totally breaks with earlier traditions, labeled correctly a masterpiece? Perhaps a masterpiece must be something completely unique, unlike anything that has come before or after it, in the tradition of the awesome Egyptian Sphinx.

Works of art that succeed in meeting such stipulations *are* typically considered masterpieces. But what about the *Venus de Milo?* It is not known as the best of Hellenistic sculpture, nor did the artist break any established conventions in its execution. And the work is surely not the only one of its type. Yet the *Venus* remains one of the most recognizable pieces of sculpture of our time. She is coolly sophisticated, perhaps even a bit disdainful, yet somehow also warmly sensual. In short, this sculpture appeals to twentieth-century sensibilities.

The art world is fickle, however, and aesthetically pleasing does not guarantee immortality as a masterpiece. Witness the ups and downs of the *Apollo Belvedere*, a Roman copy in the second century A.D. of a Greek original. The sculpture was not particularly renowned in its own time, but it was championed as a masterpiece, the very embodiment of Greek ideals, in the eighteenth and nineteenth centuries. Today, it is once again out of favor, deemed too stylized, too feminized, indeed too beautiful—therefore contrary to twentieth-century perceptions of Greek ideals.

With regard to the oldest objects of art, what designates a masterpiece is as simple as the fact of its very existence. The *Venus of Willendorf*, for example, is one of only a handful of pieces that have been discovered from her time period—extremely broadly estimated at somewhere between 30,000 and 20,000 B.C. Scholars don't know if the tiny figure—less than 5 inches (13 cm) tall—is representative of other sculpture of the time because there are so few others to compare it to. In fact, the only thing known for sure is that this *Venus* represents a woman; the pendulous breasts make that perfectly clear. She might be a sort of talisman or a goddess or the artist's

Venus of Willendorf
c. 30,000–20,000 B.C.; limestone; 4³/₈ in. high (11 cm). Naturhistoriches Museum, Vienna.
One of the oldest existing pieces of sculpture, this form of a woman might have been suggested by the natural hole in the limestone rock that serves as the belly button. Carefully carved braids or curls cover the head, rather than any facial features. Traces of pigment remain, indicating the work was once painted red.

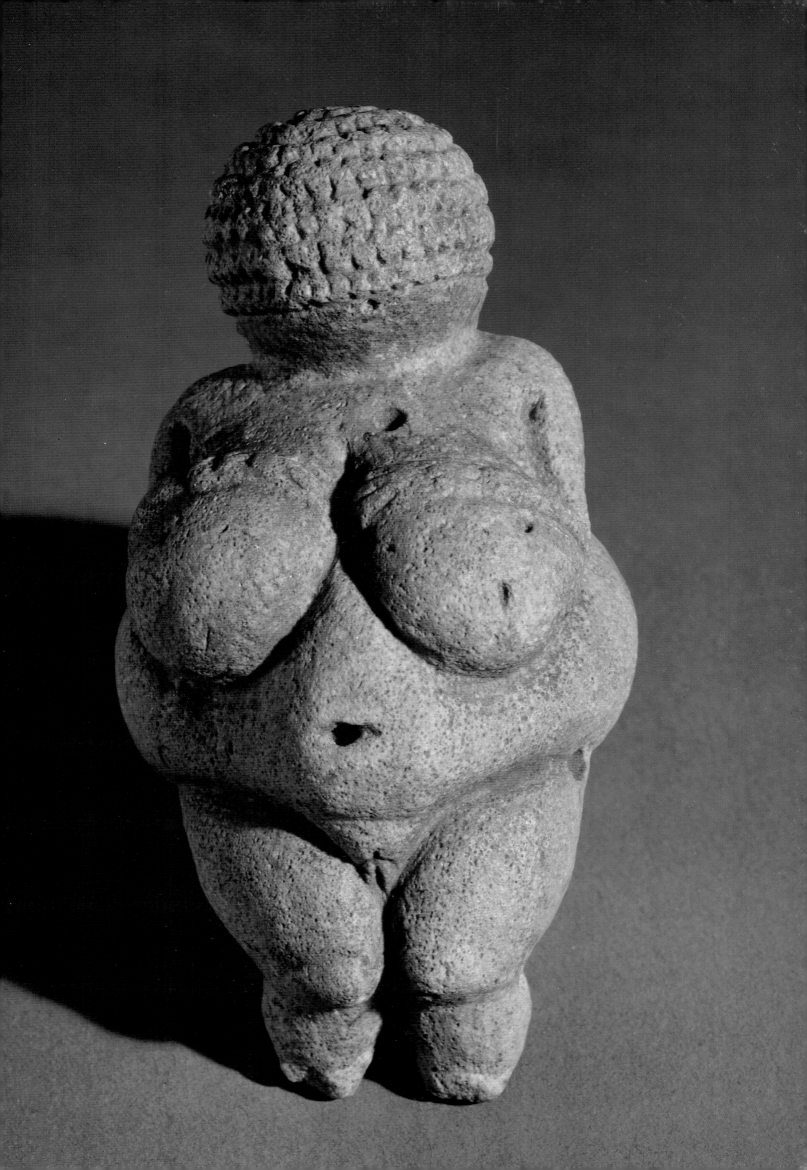

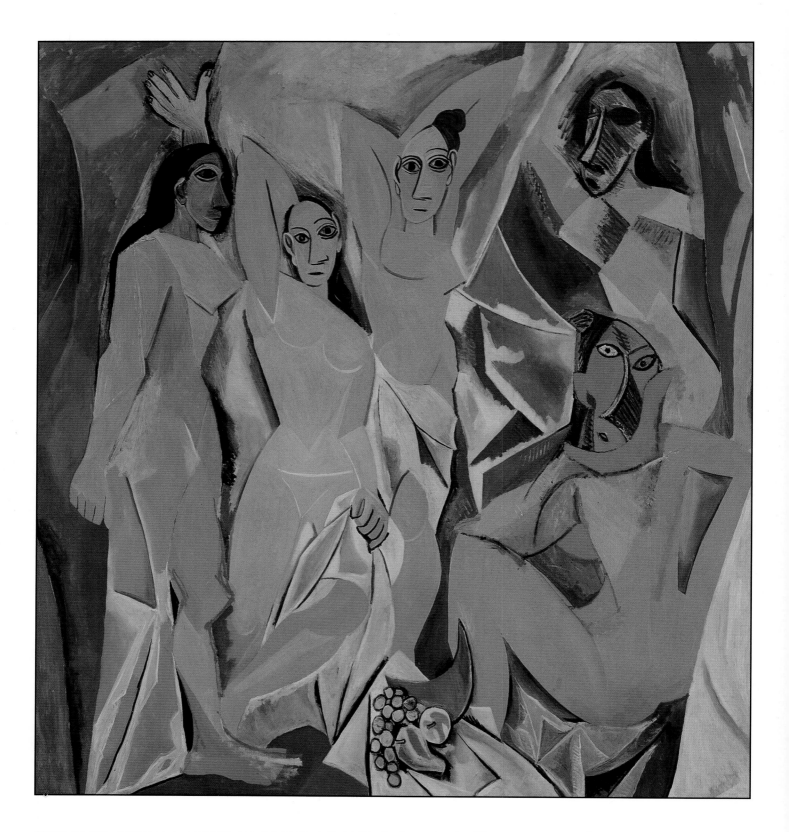

FOLLOWING PAGE:

Bison

c. 14,000–10,000 B.C.;
paint on limestone rock.
Altamira Caves, Spain.
With pigments derived
from natural substances
like ochre and hematite,
Paleolithic painters used
heavy outlines and subtle
shading to create natural-
istic pictures of bison,
cattle, and other animals.
The purpose of the cave
paintings, discovered
throughout Spain, France,
and other parts of Europe,
remains a mystery.

Les Desmoiselles d'Avignon

PABLO PICASSO (1881–1973); 1907; oil on canvas; 8 ft. x 7 ft. 8 in.
(2.43 x 2.33 m). The Museum of Modern Art, New York.
Picasso's nude and simplified figures extended the abstraction of
earlier painters to a geometric distortion of the human form that fore-
shadowed Cubism; the fragmented figures are echoed in the distinct
shards of the broken background. The masklike faces were influenced
by Picasso's fascination with primitive African and Iberian sculpture.

mother or the artist herself—without written records or other evidence, we simply do not know
who or what it represents. Clearly, though, it is not Venus, the Roman goddess of love, who
would not appear for at least another twenty thousand years!

Similarly, the Paleolithic cave paintings found at Altamira, Lascaux, and some other sites
in Spain and France immediately acquire masterpiece status by virtue of their age. Somewhere
between twelve and eighteen thousand years old, they're the oldest known paintings, although
others might still be hidden in the deep recesses of unexplored caves. If Stone Age artists
painted on other surfaces, no traces remain. These works are extremely naturalistic, capturing
both the look and the essence of animals such as bison, horses, and mammoths to the point that
authorities believed them to be a hoax when the first examples were discovered in Altamira,
Spain, in 1879.

The purpose of such paintings still eludes us, more so because they reside in the backs of
caves—sometimes accessible only by crawling through long, low spaces—and completely out
of the range of natural light. Although these early artists were capable of realistically depicting
animals in motion, there are very few human images on the cave walls. Those that do exist are
extremely simplified—virtually stick figures.

Perhaps the most amazing issue is that these paintings demonstrate how little the basic
nature of art has changed. From cave to cave, established conventions in poses are upheld:
Horses, mammoths, and bison, for instance, are always shown in profile, while deer are
portrayed with heads turned to look behind them or out at the viewer. Although we do not un-
derstand what they mean, geometric symbols sometimes appear near the animals. In addition
to outlining to provide form, artists used subtle shading to lend bulk to figures. In other words,
more than ten thousand years ago, artists were working with some of the same principles em-
ployed today: line and color to create forms; standard poses that are immediately recognizable;
universally understood symbols used as a shorthand to embellish obvious meaning.

Through the ages, the goals of art might change according to the needs and desires of a
society at a certain time, and the techniques might evolve in response to technological advances,
but the fundamental nature of art remains constant. Masterpieces of art are those that most
completely embody that nature.

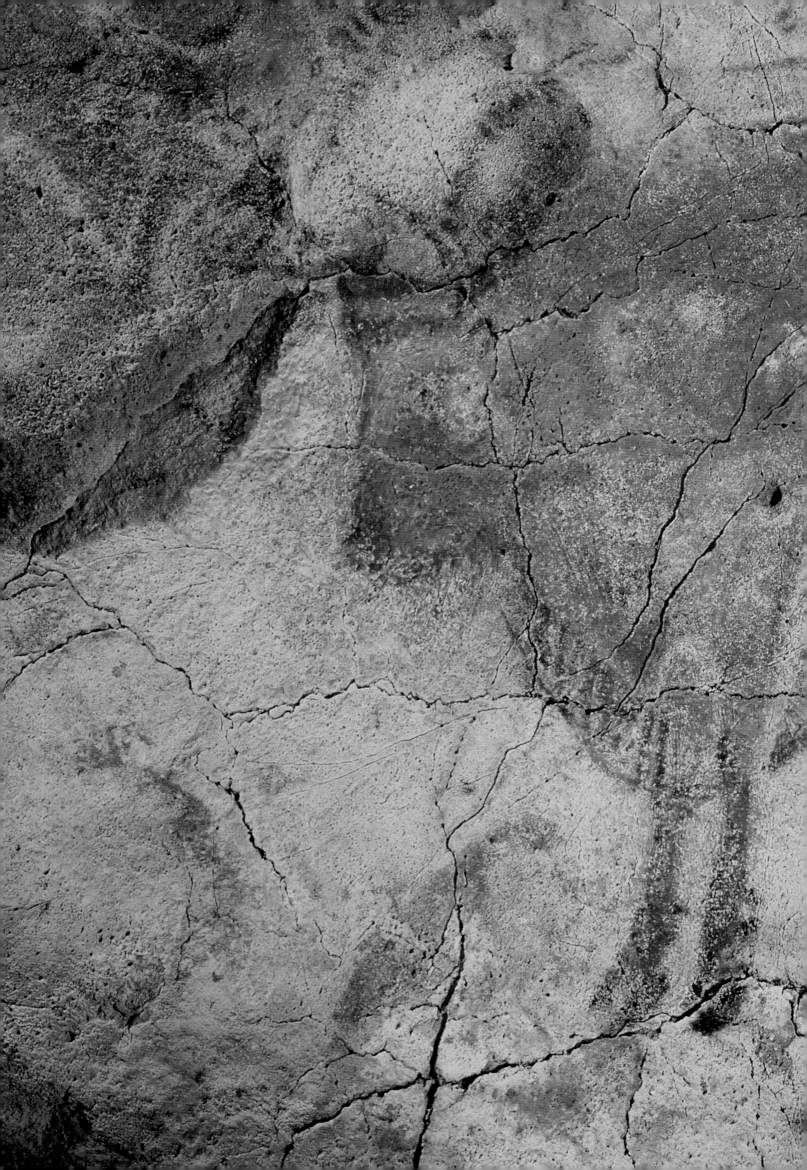

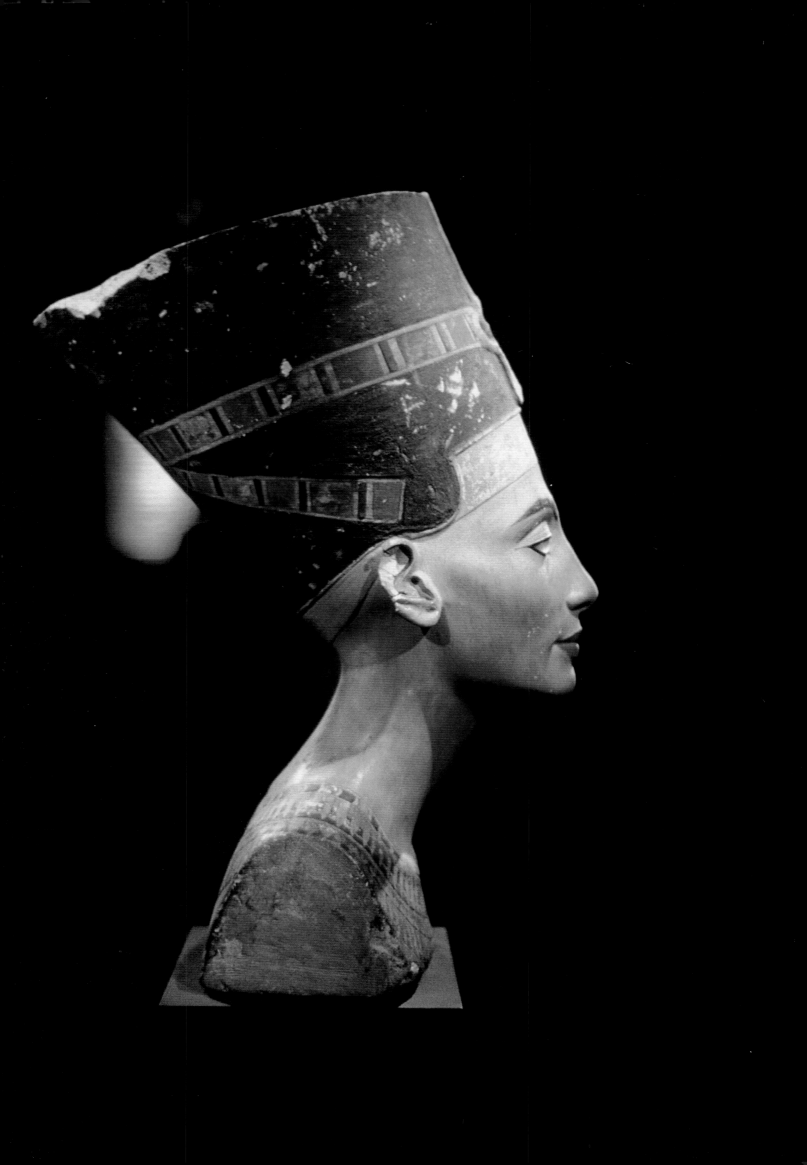

ANCIENT ART

Societies that begin to resemble later Western civilizations evolved roughly simultaneously in Egypt and Mesopotamia around 3,000 B.C., and somewhat later in the Aegean. Isolated by desert and sea in a corner of northern Africa, ancient Egyptian society changed remarkably little over nearly three thousand years—from the unification of Upper and Lower Egypt until the adoption of Hellenistic traditions with Alexander the Great's conquest in 332 B.C.

Much of Egyptian civilization revolved around their concern with the afterlife, which explains the pyramids and funerary temples built to house the bodies of noble Egyptians and the accouterments they would need in the next life. The Egyptians built on a much grander scale than any other contemporary civilizations, and with such care, precision, and scientific expertise that five thousand years later the great pyramids of Giza, the temples of Luxor and Karnak, and the monumental figure of the Sphinx still have the power to enthrall. Although the tombs of the pharaohs were robbed repeatedly through the millennia, enough of their contents remain for historians to form a surprisingly complete picture of Egyptian history and culture.

Art of Egypt and the Ancient Near East

From the earliest days of the Old Kingdom, from about 3000 to 2155 B.C., Egyptian art and architecture featured the conventions that would characterize their art through the ages. On the low-relief *Palette of King Narmer* (c. 3200 B.C.), for example, the king—probably a semimythological character who is credited with uniting Upper and Lower Egypt—is shown much larger

Scythian Stag

7th–6th century B.C.; chased gold; 12 x 12½ in. (30.5 x 31.7 cm). Hermitage Museum, St. Petersburg. Little is known about the Scythians, nomadic warriors who dominated the steppes of what is now southern Russia from the eighth through the fourth centuries B.C. This gold stag, with its body sectioned into parts and its highly stylized antlers, is representative of the culture's animalistic style of art.

Queen Nefertiti

c. 1360 B.C.; limestone; 19 in. high (50 cm). Agyptisches Museum (Egyptian Museum), Berlin. Although most Egyptian art was highly formalized and idealized, there were brief periods of realism. Beautiful, elegant, and graceful, Queen Nefertiti nonetheless looks like an actual person—complete with slight wrinkles at the sides of her mouth—as opposed to an idealized conception of beauty.

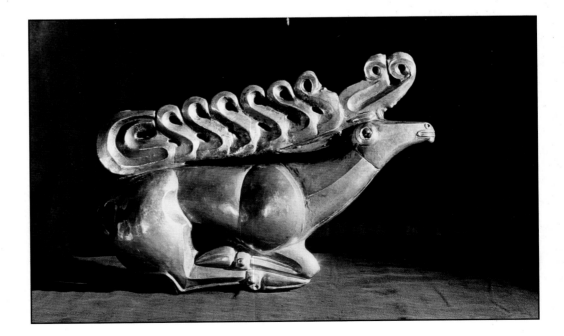

than any of the other figures to indicate his greater importance. In both low-relief sculpture and painting, the Egyptians took an intellectual approach to the depiction of figures, using what is now called fractional representation to focus on what the mind knows of the human body rather than what the eyes see. One figure, then, shows the body from numerous points of view: the front of the shoulders, torso, and eye but the side of the head and legs.

Free-standing sculpture also took its form during the Old Kingdom, mostly idealized statues of the pharaohs, seated or standing, by themselves and with their queens or their gods. Designed to perpetuate the life of the pharaoh after death, the formal statues have a strong geometric quality, with little regard for actual weight distribution. Between the legs and the arms, the spaces are not entirely carved out, so that the figures remain attached to the stone from which they come. Not until the Greeks would figures become entirely free-standing.

With some exceptions, painting and sculpture remained essentially unchanged during the later Middle and New Kingdom periods. The pyramids, however, would never again achieve

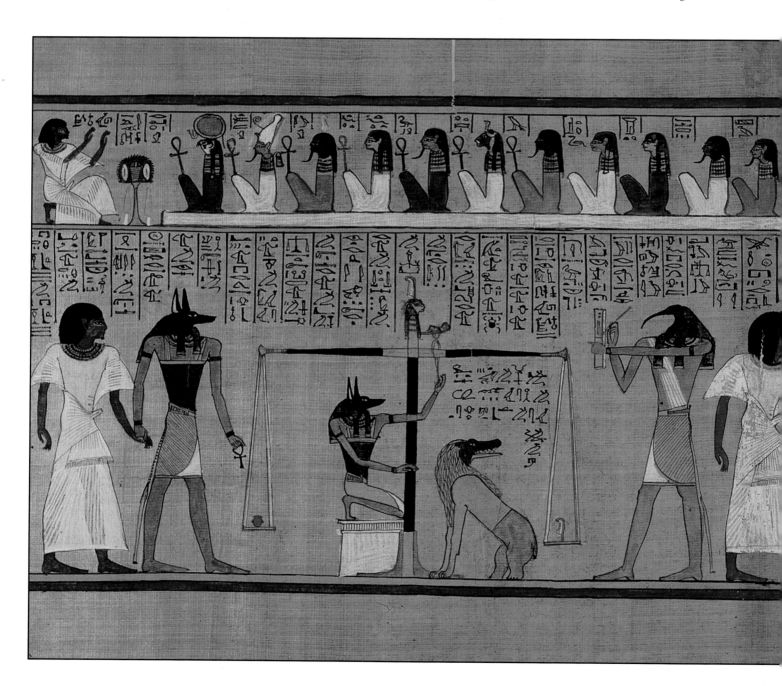

the splendor reached during the Old Kingdom, when the step pyramid of Zoser, built around 2600 B.C. evolved to the famous smooth-sided pyramids at Giza, around 2500 B.C.

One brief period during the New Kingdom is especially notable for its increased naturalism. In the fourteenth century B.C., the pharaoh Akhenaton ejected the god Amon and the traditional pantheon of gods, replacing them with a single sun god, Aten. During this time, called the Amarna period for the site where Akhenaton established his new capital, sculpture and painting became more relaxed and individualistic. Akhenaton's wife, the beautiful Queen Nefertiti, was immortalized in an elegant, well-known bust during this period, and much of the art found in the tomb of Tutankhamen, who directly followed Akhenaton's reign, retains traces of this new realism. Later art, however, returned to the more conventional and ritualized formulas of the earlier rulers.

Throughout their long history, the Egyptians had contact, including trade, with the other societies flourishing in the area at the same time, although none remained as stable as the

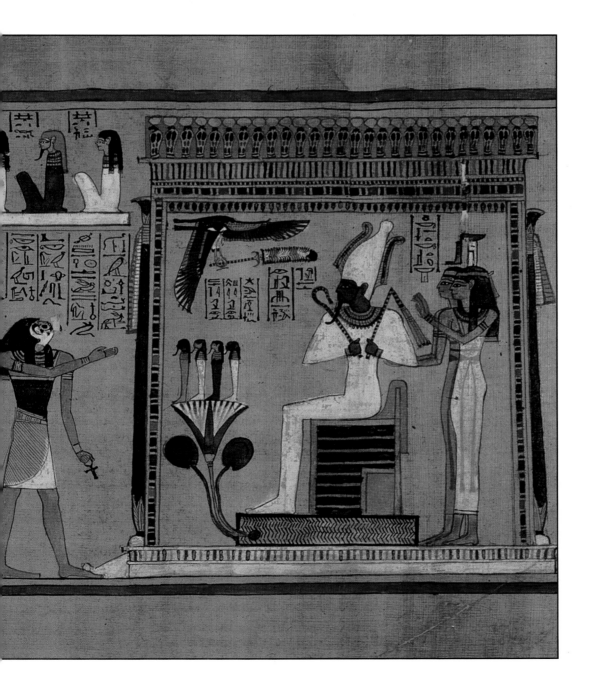

Last Judgment Before Osiris, from the Book of the Dead of Hunefer
c. 1300 B.C.; painted papyrus; 2³⁄4 in. high (7 cm). British Museum, London.
In this scene from the Egyptian Book of the Dead, a compilation of songs, hymns, and prayers to guide the dead in the afterworld, figures are portrayed in the traditional Egyptian style with the head and legs in profile, and the torso, shoulders, and one eye facing forward.

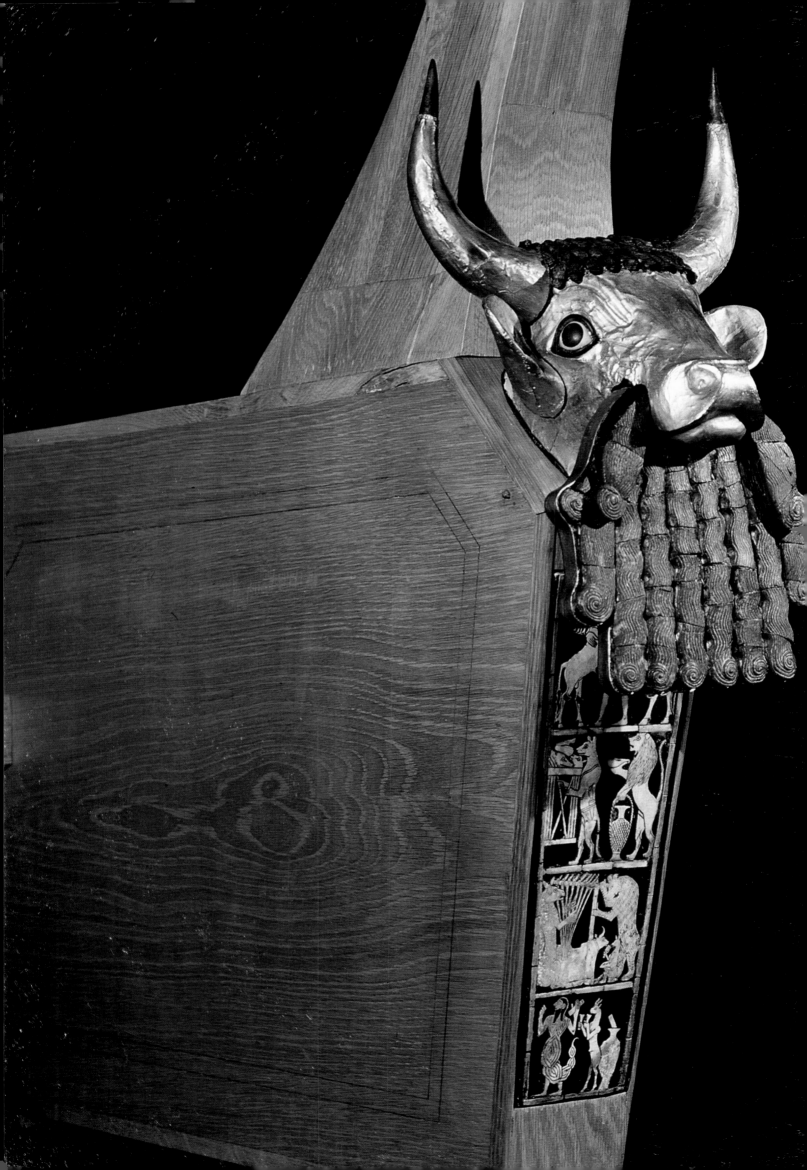

Egyptian culture. Mesopotamia, the land between the Euphrates and Tigris rivers, was wide open and therefore susceptible to numerous invasions.

The Sumerians, the first civilization in the area from 3500 to 2300 B.C., achieved great advances on par with the Egyptians: cuneiform, the earliest known writing in the world; a numerical system; and *The Epic of Gilgamesh*, a tale that is still read after more than four thousand years. In addition to ziggurats such as the one that remains in Ur, the city of the biblical Abraham, carved stone figures have been found that are as formalized as those of the Egyptians. Although the features vary, they all have large, staring eyes, complete with white shell surrounding black stone or lapis lazuli; highly stylized hair and beards; hands clasped in the position that is now associated with Christian prayer; and conical skirts. Other figures, made of hammered gold, were less formalized and more fluid and realistic—even though they often portrayed figures that mixed human and animal traits, such as bearded bulls.

The first of numerous invasions came in 2300 B.C. when the Akkadians proclaimed themselves kings, followed over the next two thousand years by the Babylonians, Hittites, Assyrians, Persians, and finally the Greeks. As each culture conquered and melded with the preceding one, art styles changed to reflect the

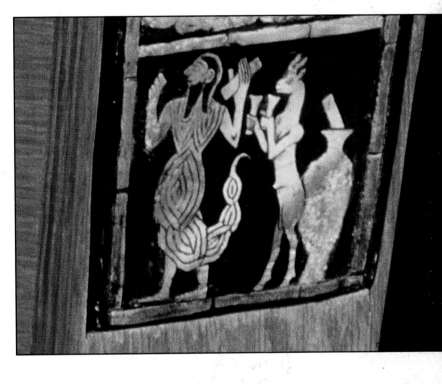

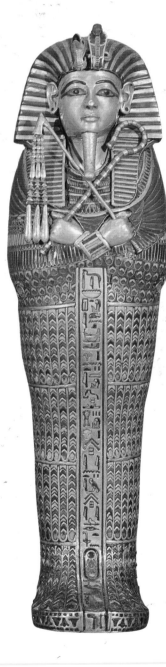

Soundbox of a Harp

c. 2685 B.C.; gold, lapis lazuli, and shell inlay; about 17 in. high (43 cm). The University Museum of Archaeology and Anthropology, Philadelphia. Sumerian figures often combined realistic elements of humans and animals, such as this bull with the beard of a human found in the royal cemetery at Ur. The beard, hair between the horns, horn tips, and eyes are all made of lapis lazuli, which had to be imported 2,000 miles (3,200 km) from ancient Sumer.

Cover of the Coffin of Tutankhamen

c. 1340 B.C.; gold, inlaid with enamel and semiprecious stones; 6 ft. ⅞ in. high (1.85 m). Egyptian Museum, Cairo. Discovered in 1922, the tomb of King Tut is the only known tomb in the Valley of Kings to have escaped plundering in antiquity. Among the stunning treasures was his 250-pound (112.5-kg) gold coffin, carved with an idealized image of the pharaoh that retains only traces of the naturalism of the previous Amarna period.

Soundbox of a Harp

detail; c. 2685 B.C.; gold, lapis lazuli, and shell inlay. The University Museum of Archaeology and Anthropology, Philadelphia. One of four panels inlaid with shell, this scene shows a combination scorpion-man and a goat both performing human-type activities, perhaps illustrating a scene from Sumerian mythology. The pose of the man is similar to those used by the Egyptians, although the goat is shown in full profile.

Snake Goddess

*c. 1600 B.C.; faience; 11⅝ in.
high (29.5 cm). Archaeological
Museum, Herakleion, Crete.
As in many ancient societies,
the primary deity of the
Minoans was a goddess
associated with serpents.
With her very human
form, imposing stance,
and contemporary clothing,
it is unclear whether this
figure, found in the palace
at Knossos, represents
the goddess herself,
a priestess, or a ruler.*

priorities of the new leaders, so that Akkadian art, for example, conveyed belief in the absolute power of the monarchy, while Assyrian art focused almost entirely on battles and Persian art highlighted ornamental and decorative aspects.

Another civilization that would greatly affect Western art evolved in the Aegean, separate from the Mesopotamians and the Egyptians, but again in contact with them through trade. Little remains from the oldest of these civilizations, who lived in the Cyclades islands, but the Minoan civilization developed on the nearby island of Crete around 2000 B.C. The huge palace at Knossos, rediscovered and reconstructed at the beginning of the twentieth century, is so large and has so many rooms that it is believed by some to be the origin of the Greek legend of the labyrinth built by Daedalus for King Minos. Palaces were decorated with colorful wall paintings of figures in motion, such as dolphins frolicking and youths jumping over bulls, completely unlike the static Egyptian figures. Also unlike in Egypt, the Minoans produced virtually no historical or religious art, with the possible exception of female figures holding snakes. With bared breasts and long, flounced skirts, the figures might have represented a goddess, priestess, or something else as yet beyond the understanding of archaeologists.

The power of the Minoans appears to have diminished rapidly after 1400 B.C., but many of their traditions lived on in the Mycenaeans, who flourished on mainland Greece from around 1600 to 1200 B.C. The culture's remaining art, found in tombs and palaces, includes numerous pieces of gold, such as inlaid gold work on the blades of bronze daggers, a solid gold funeral mask, and gold cups with exquisitely realistic reliefs of bull trapping.

Around 1200 B.C., the Mycenaean civilization began to decline for reasons that are still unknown. Eventually they were overwhelmed by invading tribes from the north, most notably the Dorians and Ionians, and the entire region fell into a kind of dark age for several hundred years. Writing ceased and little art of any kind was produced again until 800 B.C., when a new script evolved and the arts once more began to flourish.

The Great Sphinx

*c. 2500 B.C.; 187 ft. x 65 ft. (57 x 19.8 m).
Photograph by Charles Bowman. Giza, Egypt.
The pharaoh Chefren had the Sphinx constructed to guard his monumental pyramid
at Giza, outside of present-day Cairo. A mythological creature, a sphinx usually featured the
body of a lion, capped with the face of a person.
Before the face was damaged during Islamic
times, it probably bore the likeness of Chefren.*

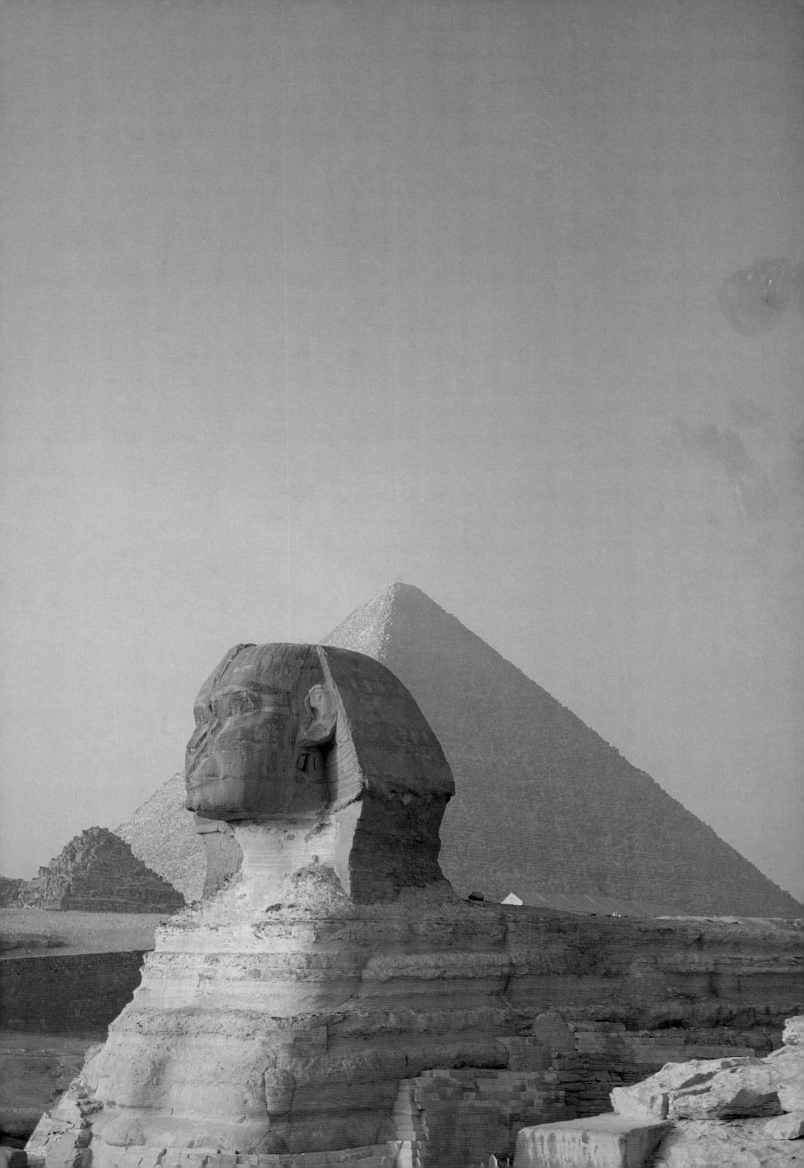

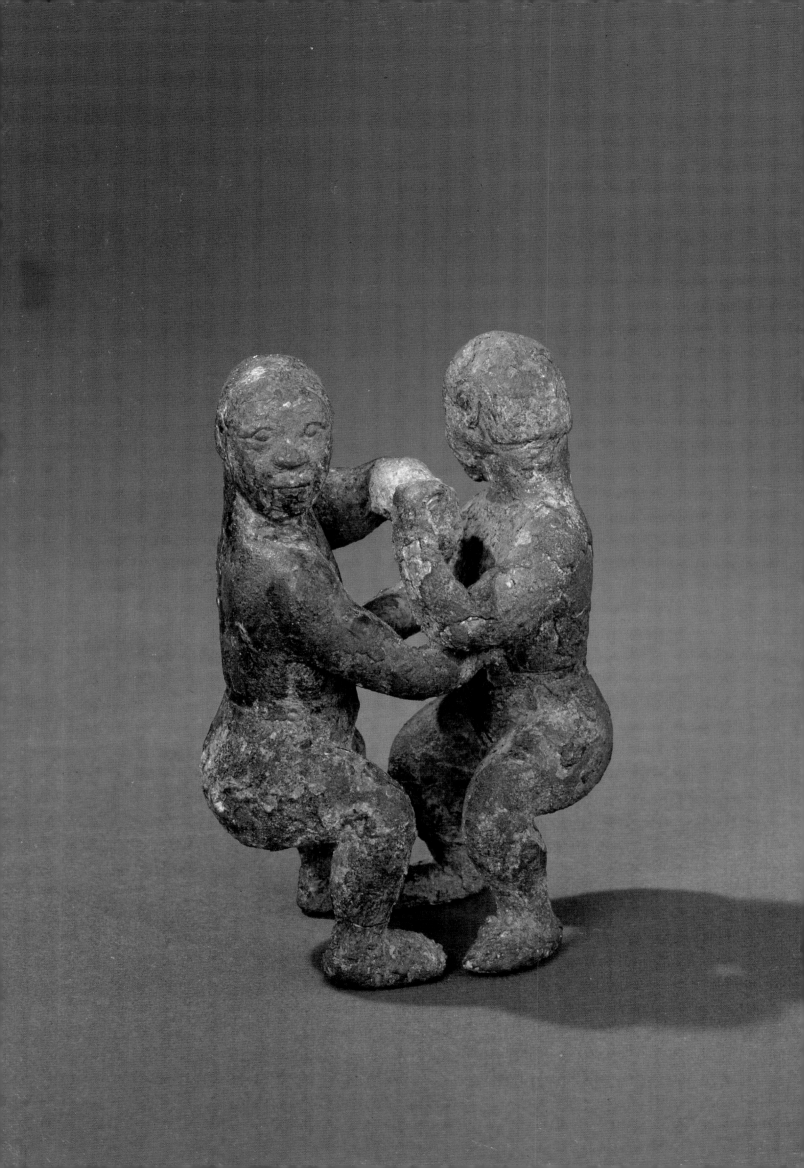

Art in the Ancient East

While great civilizations were developing in the Near East and the Mediterranean, other advanced cultures were evolving farther east. In the Indus Valley, roughly comparable to modern-day Pakistan, the ancient cities of Mohenjo-Daro and Harappa thrived from about 2300 B.C. to 1750 B.C. These sophisticated cities—built in a grid pattern, with water and sewage systems leading directly to private houses and agricultural centers, the first known evidence of long-term city planning—were completely unprecedented in any civilization, and after their abandonment nothing comparable would appear for another thousand years.

Although remains indicate the exchange of goods and communication with the Sumerians, these two societies were very different, most notably in that no evidence has ever been discovered of any large tombs, palaces, temples, or even large-scale art in the Indus Valley. The sculpture that does remain is much more naturalistic than other sculpture of the time, clearly not intended to idealize either a king or a god but to portray actual humans. Rounded, solid forms, the figures are conceived fully in the round, and the twisting pose typical of later Indian art is foreshadowed with figures that appear to be in the act of dancing.

Eventually the early culture of the Indus Valley was supplanted by the Indo-Europeans, also called Aryans, who started to move into the area

Female Figure
c. 2300–1750 B.C.
(Indus Valley culture);
terracotta. National
Museum of India,
New Delhi.
Found in Harappa, this male figure in action foreshadows later Eastern art, in which the dancing pose is so important. Like the dancing girl, it shows a concern with a faithful, rather than idealized, rendering of the human form in movement.

**Wrestlers
(or Acrobats)**

*Bronze; c. 400 B.C.; 6 in. high
(15.2 cm). British Museum, London.*
In contrast to the idealized athletes of their Greek contemporaries, Chinese art of the Zhou Dynasty is much more naturalistic. The two figures here, their knees bent as they engage either in wrestling or some form of acrobatics, are mirror images unified by their joined hands.

The Birth of Buddha

Late second/early third century A.D.; stone pedestal; 20½ in. long (52.1 cm). Art Institute of Chicago. Influenced by Greek and Roman ideals, Indian art of the Gandhara period combined Western conventions with Eastern subject matter and traditions. The Buddha appears in the center from the side of a Roman-style matron whose hand reaches up to hold the sacred Indian tree.

around 1500 B.C. Although they developed the rich Vedic culture that was a precursor to Hinduism, few works of art survive. In fact, little art other than some small sculpture exists from before the third century B.C., when Buddhist art began to proliferate.

Siddhartha Gautama, the Buddha or "Enlightened One," lived in the fifth century B.C. and by the third century B.C., Buddhism had spread throughout India. Although early Buddhist art included figures of male and female deities associated with Buddhism, the Buddha himself did not appear in sculpture as a human figure until after the first century A.D.; prior to then he was represented by images of a wheel, lotus flower, or throne. When artists started to portray the Buddha as a human, they frequently included those older images.

Two distinct styles evolved for representing the Buddha. In the Gandhara region, in what is now Pakistan, artists adapted many of the stylistic conventions of the Greeks who had been ruling there, so that these earliest Buddhas actually look quite Western, with classically noble expressions and positions. Behind some are the same haloes that would be used two centuries later to express the divinity of the Christ figure. Other trademarks of these Buddhas derive from Indian conventions, however, such as the elongated earlobes which indicate his attention to the mysteries of the earth and the jewel in his forehead symbolizing the third eye, or inner wisdom.

At the same time, another style evolved in Mathura, in central India, that was more distinctively Indian, with more natural, forceful features. By the fourth century A.D., the two styles had merged into the Gutpa classical style: natural and graceful, embodying both the spirit of the divine and the essence of humanity.

The Gutpa Buddha became the prototype for images of Buddha around the world, following the silk routes from northern India to central Asia and into China, where Buddhism had been

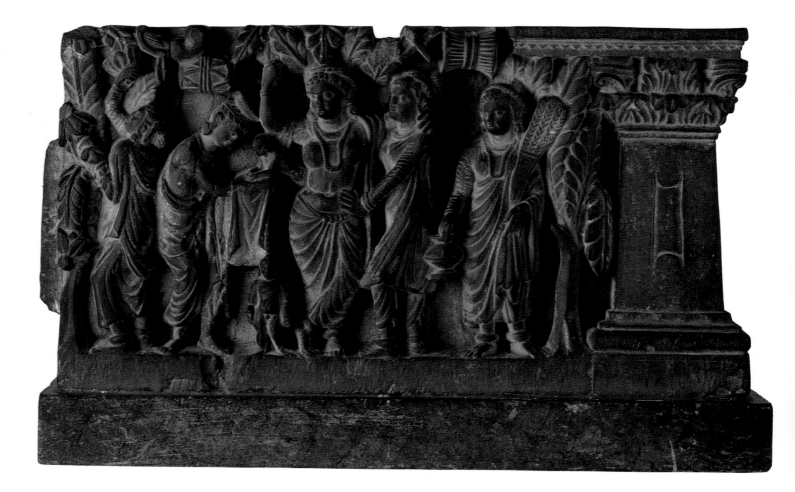

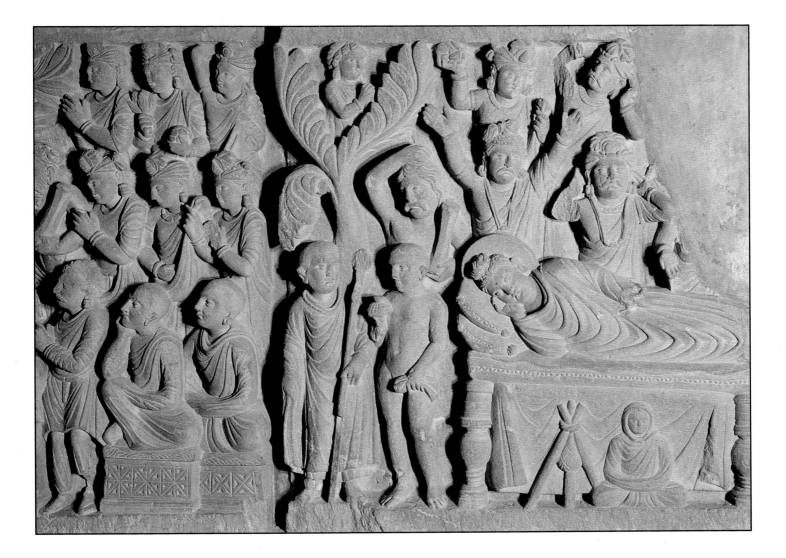

introduced in the first century A.D. Although from the third to sixth centuries A.D. art in China became almost exclusively religious based on Indian innovations, China had its own long history of artistic development, one that surpassed even the remarkable continuity of the ancient Egyptians.

From the Bronze Age to the present, Chinese art has retained the same basic features, although it has on occasion been open to foreign influences, as in the case of the Indian-style Buddhas. Pottery dating to the fourth millennium B.C. and jade from the third millennium B.C. evolved into the extraordinary bronze ritual vessels of the Shang Dynasty in the second millennium B.C. Arguably the most sophisticated vessels in design and technique of the time, they featured rounded rectangles, spirals, and other geometric forms that together created symbols with meanings that still elude historians. The *t'ao-t'ieh* monster mask was developed at this time—a kind of dragon that would be embellished through the centuries, at times believed to be a storm god, wine god, and monster.

The art of the following Zhou Dynasty, beginning around 1045 B.C., was built on that of the Shang Dynasty, with larger, more ornamental bronze vessels decorated with bold projections and distinct patterns. Other innovations at this time include an increase in the popularity of

The Death of the Buddha

Late second/early third century A.D.; dark gray-blue slate; 26³/₈ in. high (67 cm). Freer Gallery of Art, Smithsonian Institution, Washington, D.C. Dressed in togas and flowing drapery, the classical figures on this frieze from the Indian Gandhara period would not look out of place on a Roman sarcophagus. While some of the disciples grieve expressively, the small man in front of the death bed practices the Buddhist art of meditation.

21

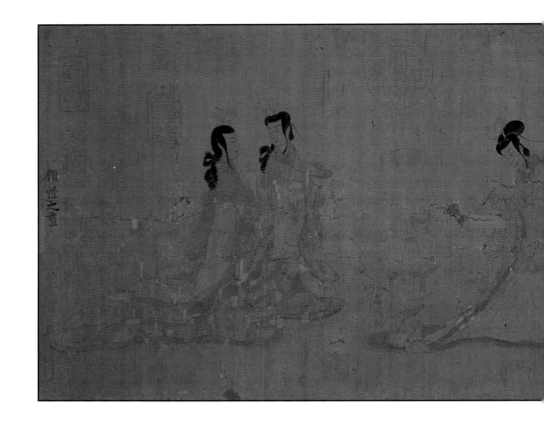

The Flying Horse
2nd century A.D.; bronze;
13¹/₂ x 17³/₄ in. (34.3 x 45 cm).
Historical Museum, Beijing.
Han Dynasty artists were
adept at capturing lifelike fig-
ures in vigorous movement,
such as this galloping horse,
found in the tomb of the
governor-general Zhang at
Wuwei in Gansu. The horse's
right rear hoof comes down
on a swallow, perhaps a refer-
ence to the name of the horse.

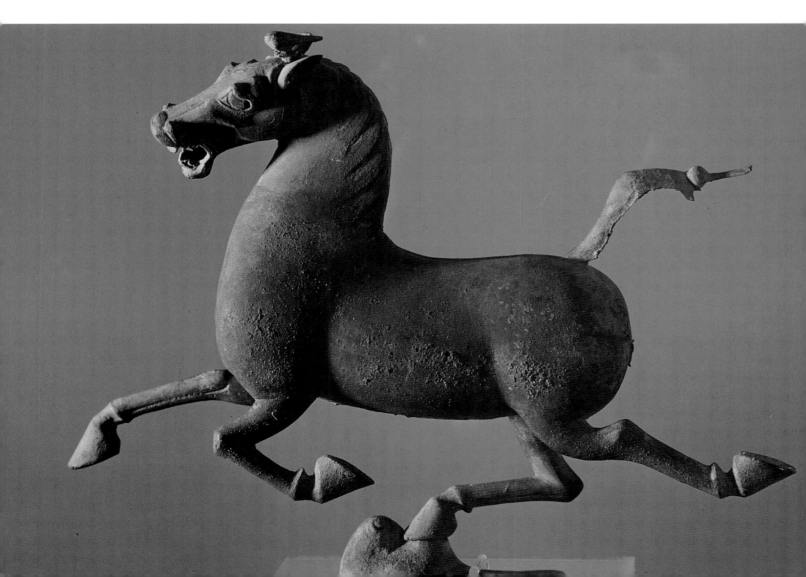

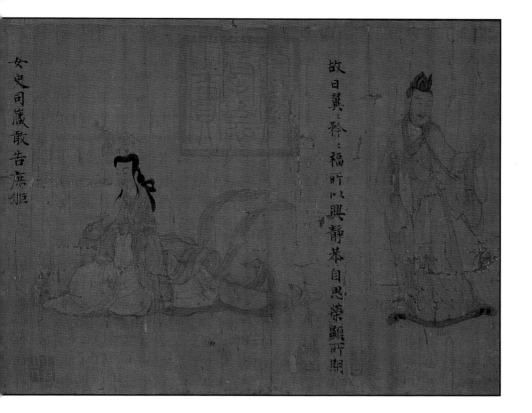

故日翼二矜三福昕以興静恭自思榮顯昕期

女史司箴敢告庶姬

**Admonitions of
the Instructress to
the Court Ladies**
*10th-century copy of original by
Gu Kaizhi (c. A.D. 345–c. 406);
hand scroll, ink and color
on silk; 9¾ in. x 11 ft. 6 in.
(24.8 cm x 3.5 m).
British Museum, London.*
Considered the first Chinese
portrait artist to capture the
spirit of his subjects, Kaizhi
was a major influence on
later painters. As court
painter, he was responsible
for creating this hand scroll,
with a narrative of events and
explanatory text on the rules
and behavior of court life.

secular art in the form of hunting and war scenes. In contrast to the noble athletes of Greek artists, Chinese artists created naturalistic sculpture, apparently designed solely to give pleasure to the viewer, with no ritual or religious meaning attached.

It was under the Han Dynasty, which began in 206 B.C., that Buddhism was introduced to China as an alternative to the already existing religions of Confucianism and Taoism. During the Han Dynasty, China's strong central government allowed for expansion and a rich literary and artistic culture. In sculpture and painting, figures became fluid, displayed in full motion. The horse, for example, a popular figure throughout Chinese history, gallops in completely free-standing sculpture while in paintings ducks flee from hunters.

Like Greek art, though, most Chinese painting is known only through later copies that may or may not convey the full import of the originals. After the Han Dynasty, the Six Dynasties period began in the south, where non-Buddhist painting rose in prominence in the mostly Confucian area. During this period, Xie He wrote a treatise on painting that would dominate Chinese ideals of painting for centuries to come, including the concepts of fidelity to the object in portraying forms and in applying color.

It was also during this period that Chinese art, and by extension what it had absorbed of Indian art, began to influence art in Japan. Although Japan is separated from the Asian mainland by only 94 miles (151 kilometers), until the sixth century A.D. it had remained isolated from cultural and artistic influences of China and Korea. Japan's own artistic tradition can be traced back as far as the ninth century B.C. and the beginning of the Jomon culture. Jomon, or "rope," was coined to describe the winding cord motif that covers the hand-built pottery vessels of the time period. Early Japanese art included pottery and figures in fantastic shapes with bold patterns; later Japanese art would mirror the trends in other Asian countries.

FOLLOWING PAGE:
**Tomb of Emperor
Ch'in Shin Huang Di**
*c. 221–209 B.C.; terra-cotta;
life-size. Photograph by
Dennix Cox. Lintong, near
Xi'an (Shaanxi), China.*
A battalion of more than
six thousand life-size pieces
guarded the tomb of Ch'in
Shin Huang Di, under
whose rule China as a
country emerged for the
first time and the Great
Wall was constructed.
The body of every piece
is identical, but the head
and hands of each one
were modeled individually.

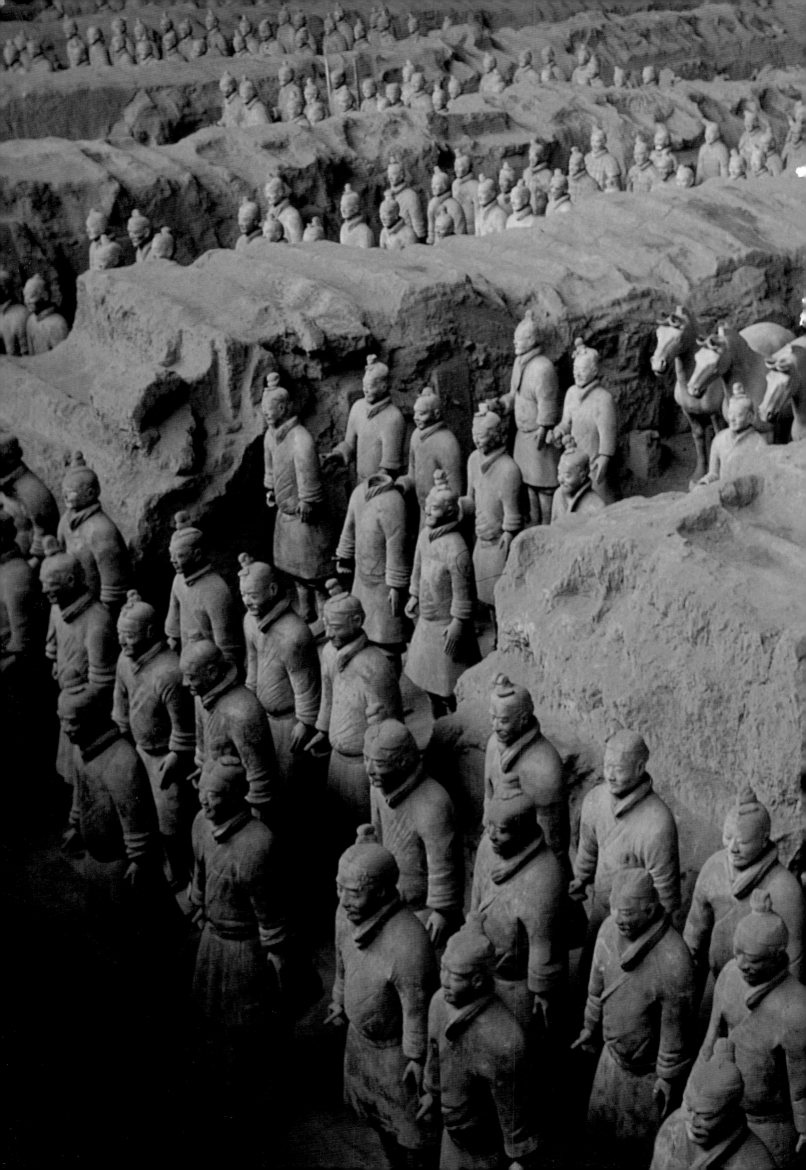

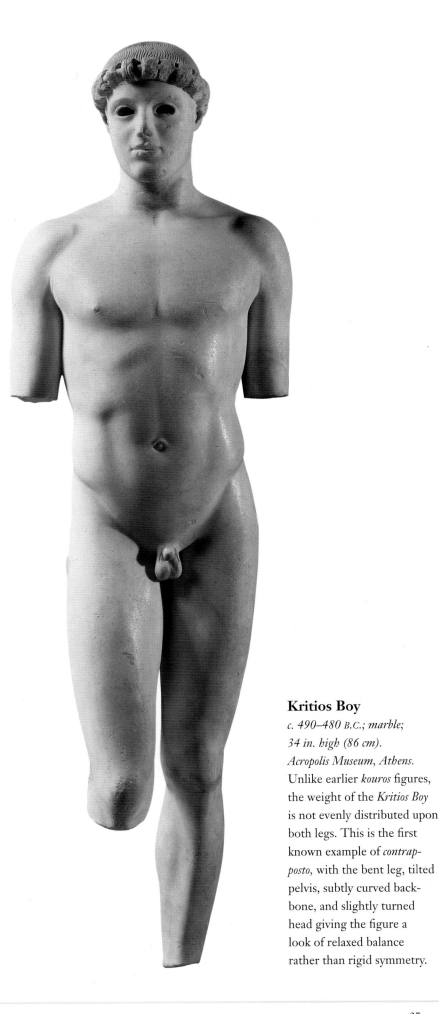

Greek Art

Dorian and Ionic invaders took over, around 1200 B.C., what would later be known as Greece, but they do not appear to have brought any artistic traditions with them. It is amazing then that the descendants of these peoples, together with the Minoan and Mycenaean cultures that were absorbed, would some four hundred years later begin to develop the art that would have such a profound effect on Western civilization. Time and again, the foremost artists of the Western world would consider Greek art the ideal. For more than two thousand years, Roman artists, Renaissance artists, and nineteenth-century Neoclassical artists have looked to the Greeks for inspiration, seeking to understand and perfect the principles established by them.

How did the Greeks reach this apex? The earliest Greek art was relatively simple: continuous or repeated geometric patterns on vases. Eventually the stripes, dots, diamonds, circles, and other patterns evolved into simplified representations of animals and humans, also repeated with little variation and still a minor part of the overall design. While Homer was composing the *Iliad* and *Odyssey* in the ninth or eighth century B.C., Greek artists were just beginning to recount simple series of events on vases.

Achilles and Ajax Amphora
Exekias; c. 550–530 B.C.; 24 in. high (60.7 cm). Vatican Museum, Rome.
By the end of the seventh century B.C., vases featured scenes from mythology, with figures of gods, humans, and animals rather than just geometric patterns. Inscriptions identified the characters, as well as attributing the artist. The signature here reads: "Exekias painted me and made me."

Kritios Boy
c. 490–480 B.C.; marble; 34 in. high (86 cm). Acropolis Museum, Athens.
Unlike earlier *kouros* figures, the weight of the *Kritios Boy* is not evenly distributed upon both legs. This is the first known example of *contrapposto*, with the bent leg, tilted pelvis, subtly curved backbone, and slightly turned head giving the figure a look of relaxed balance rather than rigid symmetry.

Meanwhile, increasing prosperity and political stability led to the full development of the *polis*, or city-state, as well as a great wave of colonization and increased trading with other cultures in the Near East.

As the Greeks came into contact with the arts of Egypt, Assyria, and Mesopotamia, they adopted the decorative motifs of these cultures, such as spirals and rosettes, and became more concerned with illustrating stories, most often familiar scenes from Greek legends, with inscriptions to identify the players and others to proclaim the artist. Influenced by Egyptian sculpture, Greek artists would go on to create their own monumental sculptures.

Like Egyptian figures, the typical Greek male figure of this Archaic period—called a *kouros* ("youth")—stands with one foot placed forward, his arms straight down by his sides with clenched fists, head held high. The female figure—or *kore* ("maiden")—varies more than the male figures, but is usually defined by a narrow waist, one arm held up against her chest, and long wiglike hair. Although the forms were clearly Near Eastern, the Greeks imbued these figures with their own sensibilities, so that a *kouros* was always naked and soon came to represent the ideal male athlete-god in the full bloom of youth, while the *kore*, unlike Near Eastern counterparts such as the naked Phoenician goddess Astarte, was always elaborately clothed.

At the same time, monumental architecture, with its famed Ionic and Doric orders, came into being, providing a framework for sculptures on pediments, in friezes, and sometimes as the actual columns. It is certain that painting existed at this time, but little survives except the painted black and red vases, a major art form by the sixth century.

In the fifth century B.C., after the defeat of the "barbarian" Persian armies, Athens emerged as the center of Greek culture. Today's Western civilization is influenced still by the fifth-century tragedies of Sophocles and Euripides, the comedies of Aristophanes, and the philosophy of Socrates. Buildings are still constructed in the Doric style of the Parthenon on the Acropolis, completed in 438 B.C. And artists continue to rely on *contrapposto*, a sculptural technique of balanced nonsymmetry.

The Dying Gaul

Roman copy after bronze original c. 230–220 B.C.; marble; lifesize; Museo Capitolino, Rome. Emphasizing emotion and atmosphere, this Roman copy realistically portrays a Gaul in the throes of death after defeat by King Attalus I of Pergamum. Despite the pain that is evident in both the body and face, the man dies with the dignity of a respected opponent.

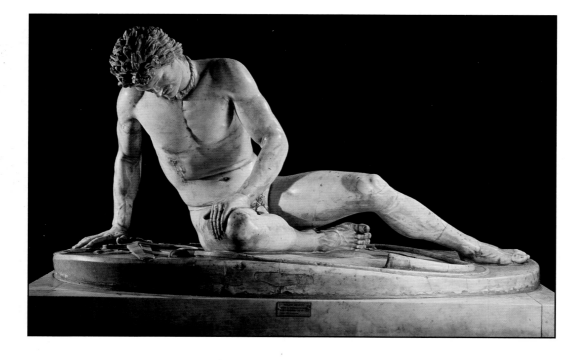

Poseidon (or Zeus)

Myron; c. 460–450 B.C.; bronze; 6 ft. 10 in. high (2.1 m). National Archaeological Museum, Athens. Rediscovered in the sea off the coast of Greece, Poseidon in the act of throwing his trident (or Zeus hurling his thunderbolt) is one of the earliest completely free-standing monumental sculptures. Like earlier works, there is still a certain formality to the figure, yet it also conveys the dignified motion of the god in action.

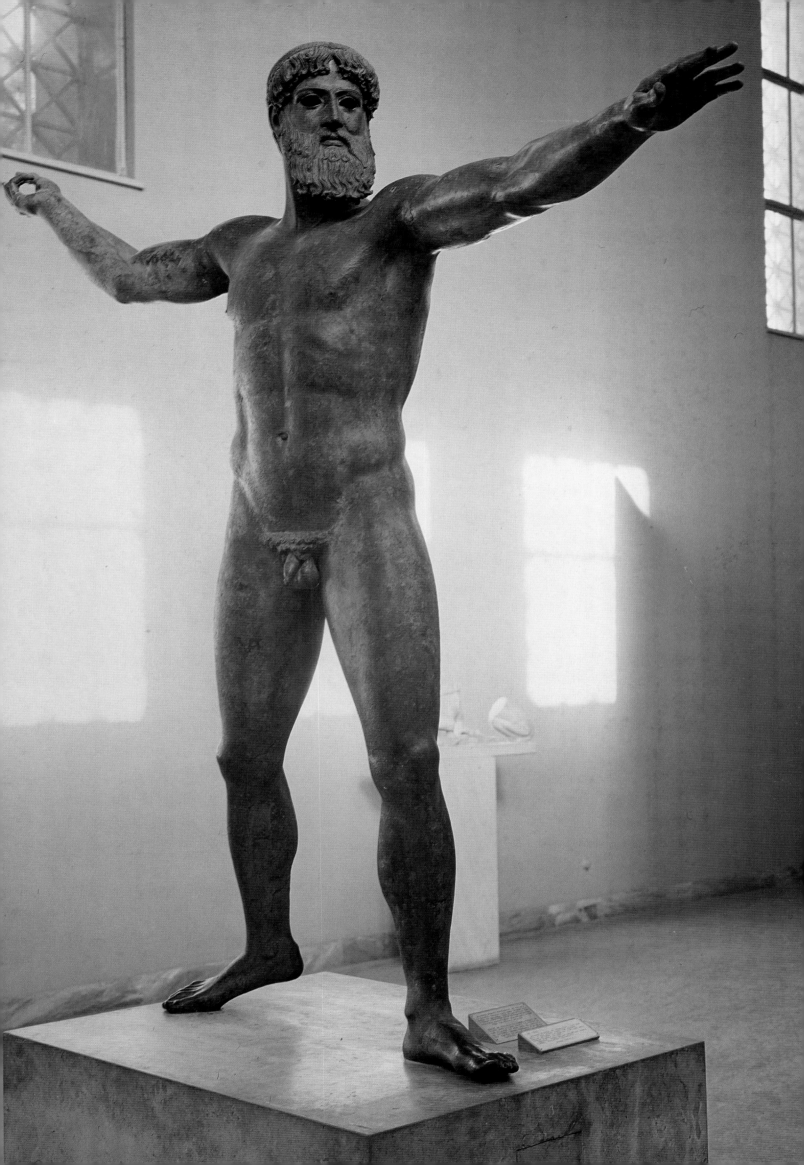

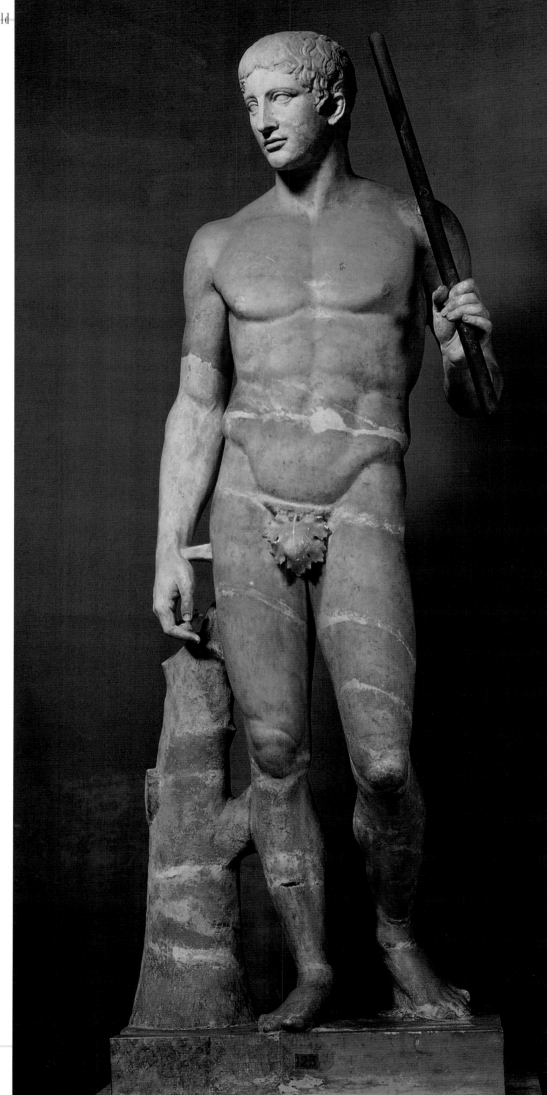

Doryphorus
(Spear Bearer)

Roman copy after a bronze
original c. 450–440 B.C.; by
Polyclitus; marble; 6 ft. 6 in.
high (2 m). Museo Archeologico
Nazionale (National Archaeo-
logical Museum), Naples.
Polyclitus of Argos is said
to have created this figure to
demonstrate his new theory
of idealized proportions,
which eventually became so
popular that it was called a
"canon." The *contrapposto*
and slight turn of the head
in the *Kritios Boy* reach full
maturity here as the figure
is caught in mid-stride.

The Kritios Boy, the earliest known example of *contrapposto*, dates to around 480 B.C. and was found in the rubble the Persians left behind when they destroyed the Acropolis. Even partially destroyed, it is clear that this figure is unlike earlier figures, in which the weight was distributed evenly on both legs. Most of this youth's weight rests on the left leg, which is lower than the bent right leg; the pelvis is twisted; the back has a subtle curve; the head inclines slightly. As a result, the figure appears to be in motion, rather than static like earlier sculptures.

Once Greek artists understood the principles of *contrapposto*, a new world opened up to them. Figures could now be forged in full, realistic motion, reflecting the natural rhythms of the body. Depictions of the human body became more realistic, more in balance, less perfectly symmetrical. Yet the Greeks also saw the human body as the embodiment of everything noble and their art reflected this in idealized human forms that were dignified and handsome, heroic and godlike, with no apparent imperfections.

No painting survives from this classical period; however, the names of the masters—Apelles, Micon, Parrhasius, and others—live on in Greek writings. Original sculpture fared no better, but copies the Romans later made of the masterpieces do exist. Although the copies are thought to be poor imitations of the originals, they retain the sense of balance of Myron's coiled *Discobolus* (*Discus Thrower*) and Polyclitus's striding *Doryphorus* (*Spear Bearer*). Both are examples of the "canon" of idealized human proportions invented by Polyclitus and used in later classical sculpture: The measurements of the body are based on a theoretical ideal; thus, for example, the height of male figures was usually eight and one-half times the height of the head, while female figures totaled eight times the height of the head.

Sculpture from the masters of the fourth century late classical period—Scopa, Praxitelles, and Lysippus—is known as well only from Roman copies, with the possible exception of *Hermes With the Infant Dionysus* (scholars still question whether it is the original by Praxitelles or a Roman copy). In either case, it is a good example of the changes wrought in the fourth century, when sculptors included more human emotion and developed an interaction between figures and the environment that surrounded them.

After the death of Alexander the Great in 323 B.C., the huge empire he had amassed began to disintegrate into a number of individual kingdoms, and the cohesion of Greek art followed suit. Although some tried to force the golden age to live on through an imitation of its arts, the essential spirit of the time was changing.

It is difficult to summarize the works of this Hellenistic period—roughly three centuries from the death of Alexander the Great to the establishment of the Roman Empire—because so many artists were doing so many different things. While the philosopher Plato urged that artistic works should conform to some absolute standard, Aristotle believed forms in art depended upon who made it, what it was made of, and what the purpose of the art was. The result was a move toward a more realistic portrayal of human figures and emotions, increasing flourishes and romantic embellishments, even violence and ugliness.

Hermes and Dionysus

PRAXITELES (or copy?); c.340–300 B.C.; marble; 7 ft. 1 in. high (2.2 m). Archaeological Museum, Olympia, Greece. Scholars disagree as to whether this sculpture is the original by Praxiteles or a very good copy. In any case, it illustrates the more relaxed pose and softened musculature common in the later periods, as well as a tender interaction between Hermes and the infant he carries.

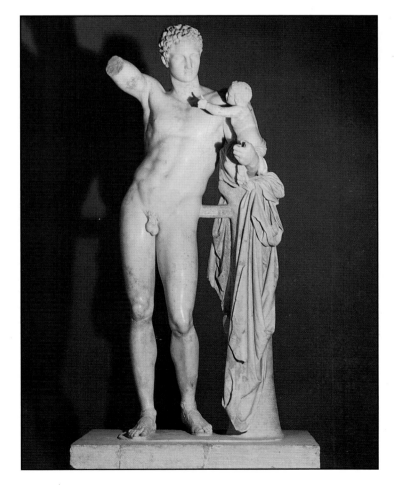

Discobolus
(Discus Thrower)

Roman copy after a bronze original c. 450 B.C.; by Myron; marble; life-size; Museo delle Terme, Rome. Several copies exist of Myron's lost *Discus Thrower*, famed for the depiction of a series of movements in one frame as the man is poised to throw the disk. The arms, legs, and torso all twist in a complex balancing act to show simultaneously the tension and impending release of the action.

Nike of Samothrace
(Winged Victory)

c. 200–190 B.C.; marble; 8 ft. high (2.4 m). Musée du Louvre, Paris. Created to celebrate a naval victory, this *Nike*, or Goddess of Victory, was originally designed to be seen as she swoops forward to descend onto the prow of a ship (no longer extant). The wind, though invisible, is a palpable presence, whipping her clothing to her body and creating a real relationship between the figure and the space around it.

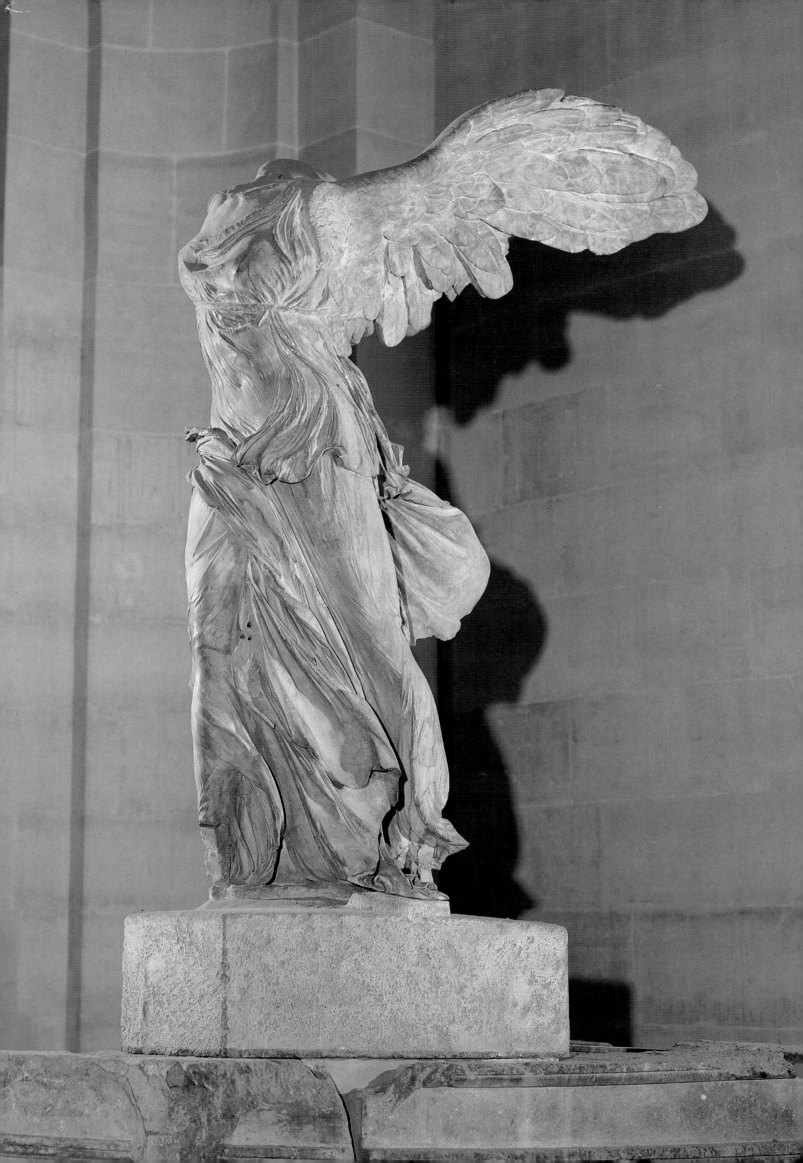

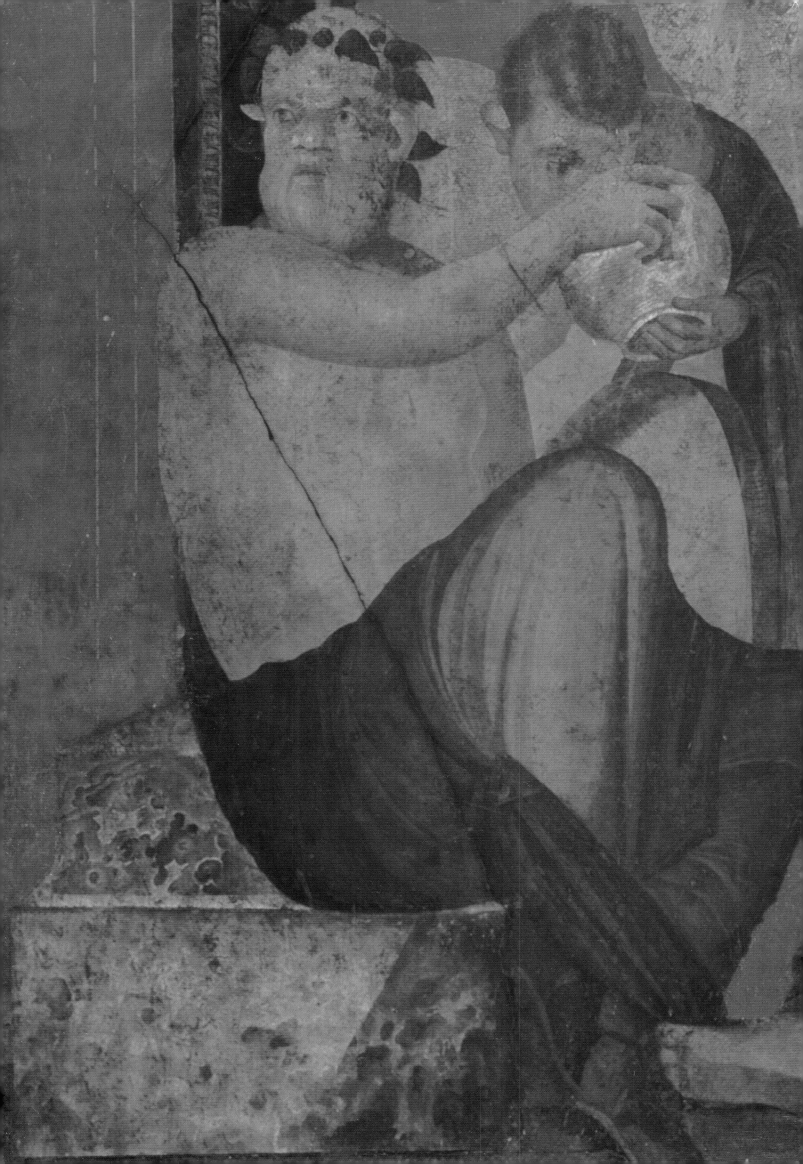

Detail from Dionysiac Mystery Cult, Villa of the Mysteries

detail; c. 50 B.C.; wall painting frieze. Pompeii, Italy.

Many of the details of the initiation rites are still shrouded in mystery, but drinking a special libation appears to be part of the ritual. From wall to wall, the painted figures interact with each other; here the glance of the man holding the bowl is distracted by a woman on the adjacent wall throwing back her cape.

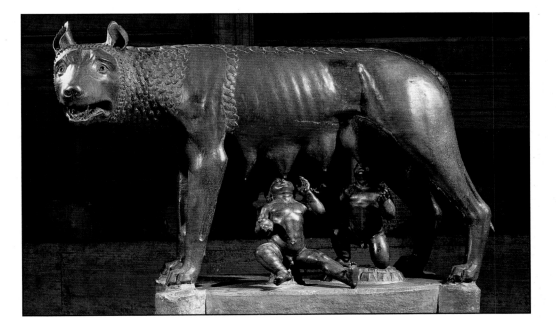

Roman Art

While the Greeks were conquering much of the Near East and perfecting their idealized human forms, the Etruscans, a people whose origins remain mysterious, were settling the Italian peninsula around 700 B.C. Just as the art of the Greeks reflected their philosophy of dignity in the human form, Etruscan art mirrors this society's concern with the afterlife. Little has survived, but what does remain is mostly from elaborate burial complexes where the focus was on commemoration and preservation in the afterlife, similar to civilizations in Egypt and Mesopotamia.

Etruscan figures tend to be smoother, more rounded, and less formal. The Etruscans also portrayed realistic figures: middle-aged, overweight men and women completely unlike the Greek ideal. Surviving tomb paintings portray animals, ritual figures, and mythological scenes, all silhouetted in bright colors with little interior modeling and less formality than Egyptian tomb paintings.

The Roman Republic was founded in 510 B.C. and by the third century, the Romans had overrun and assimilated the Etruscans, as they would do with the Greeks a hundred years later. The Romans had a profound respect for the achievements of the Greeks and much of the remaining Roman sculpture are actually copies of earlier Greek sculpture, some commissioned by Roman aristocrats for their homes. But the Romans also incorporated a rich tradition of sculptural portraiture inherited from the Etruscans.

Early Roman marble works that were not copies were often meticulous records of individuals rather than idealized conceptions of beauty. Roman artists carefully rendered the details of the faces of their sculpture, complete with wrinkles, sagging skin, and sunken cheeks when appropriate. Roman faces, whether topping statues or free-standing busts, often had a stern air that suggested the Roman ideals of power, practicality, and devotion to duty, a marked change from the calm and serene expressions indicative of much Greek sculpture.

As the Roman Empire expanded to eventually include much of the Near East, western Europe, and North Africa, its policy was to allow conquered cultures to retain their own traditions, leading to rich and diverse art forms throughout the vast empire. Unlike the Greeks,

Capitoline She-Wolf

c. 500 B.C.; bronze; 33½ in. high (85 cm). Museo Capitolino, Rome.

The fiercely protective she-wolf, which suckled the city of Rome's founders Romulus and Remus, derives from Etruscan mythology and has been a symbol of Rome from its earliest times. The vigorous and powerful wolf dates from the Etruscan period; the infants were added during the Renaissance.

the Romans recorded and celebrated their history with public sculpture, such as the Arch of Titus, representing the suppression of a Jewish revolt in A.D. 71.

Bronze sculptures to honor civic leaders and private citizens became popular, as well as equestrian statues to glorify the empire. Out of at least twenty public equestrian statues that once existed, the only one that remains is of Marcus Aurelius and that only because of an error. Early Christians mistakenly thought the statue portrayed Constantine I, the emperor who made Christianity the official state religion. During the Renaissance, the sculpture became the model utilized by numerous sculptors to portray victorious soldiers on horseback.

In addition to sculpture, the Romans made innovations in painting. Most of the surviving Roman paintings come from Pompeii and Herculaneum, two cities completely buried under thick layers of ash when Mount Vesuvius exploded in A.D. 79. When the cities were rediscovered in the eighteenth century, the sculpture, wall paintings, and floor mosaics had survived almost intact under their protective covering of ash. Although the cities were provincial outposts, not cultural centers like Rome or Alexandria, they do provide some idea of painting styles of the time.

Some of the styles had been seen before in other places, like the painted blocks or panels of stone which were common in the Eastern Mediterranean. Other scenes include simple landscapes, still-lifes, and numerous erotic paintings. The Romans employed a variety of techniques—including modeling and shadowing, foreshortening, atmospheric perspective, and overlapping—to enhance the sense of depth and perspective.

Yet other conventions appear for the first time, such as the use of painted make-believe windows looking out on landscaped scenes to increase the sense of space in a room. In the Villa of the Mysteries in Pompeii, one extraordinary room is painted with initiation rituals into the Dionysiac mystery cult. Mortals and gods play their parts standing atop a painted platform that runs around the entire room to form a sort of stage for the action. In one instance, a woman painted on one wall raises her whip to strike a woman who is painted on the adjacent wall; anyone standing between them feels as though he or she is interrupting real action.

Scenes of Dionysiac Mystery Cult, Villa of the Mysteries

c. 50 B.C.; wall painting frieze; 5 ft. 3¾ in. high (1.62 m). Pompeii, Italy.

Like actors in a play, the nearly life-size figures stand on a painted stage against a deep red background as they perform the rituals associated with Dionysus and Ariadne. Many of their poses and gestures are classical, yet they are not idealized. Their weight and interaction with each other make the figures appear almost real.

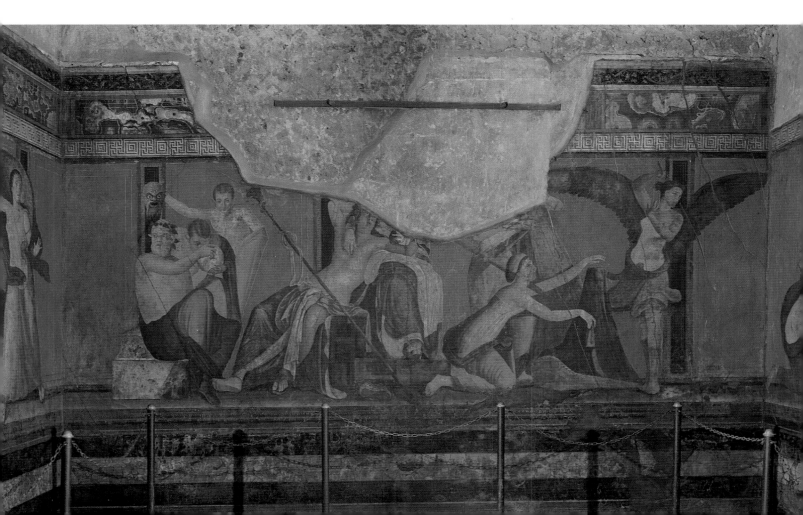

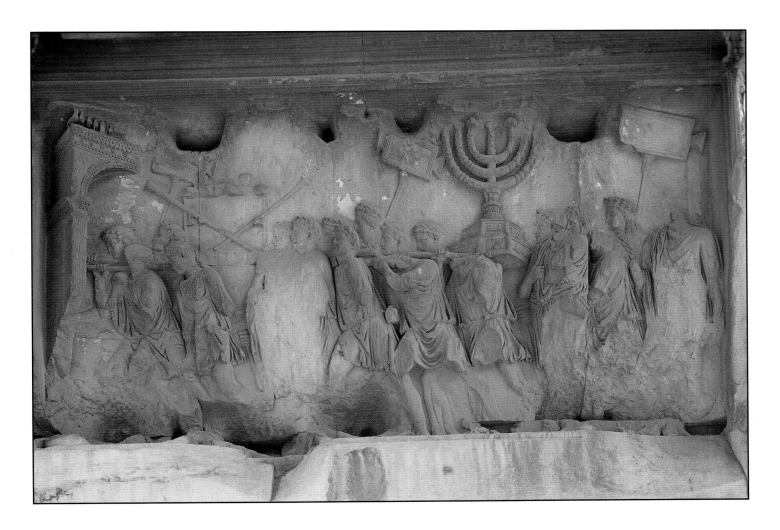

Spoils from the Temple in Jerusalem, Arch of Titus

A.D. 81; marble; 7 ft. 10 in. high (2.4 m). Rome.

The triumphal arch and the triumphal column, both decorated with relief sculpture, were two distinctly Roman architectural forms, designed to show off victories. On the inside of the Arch of Titus, the crowd carries the treasures looted from the Temple of Solomon, turning away from the viewer to march through an arch within the arch.

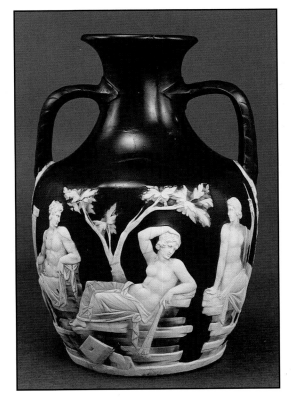

The Portland Vase

c. 27 B.C.–A.D. 14; blue and white cameo glass; 9¾ in. high (24.8 cm). British Museum, London.

In addition to monumental sculpture and painting displayed in public, the Roman Empire was renowned for luxurious items made for the individual consumption of the upper classes, such as silver vessels and reliefs on cameo glass. In this mythological scene, the miniature figures have all the grace and style of their larger counterparts.

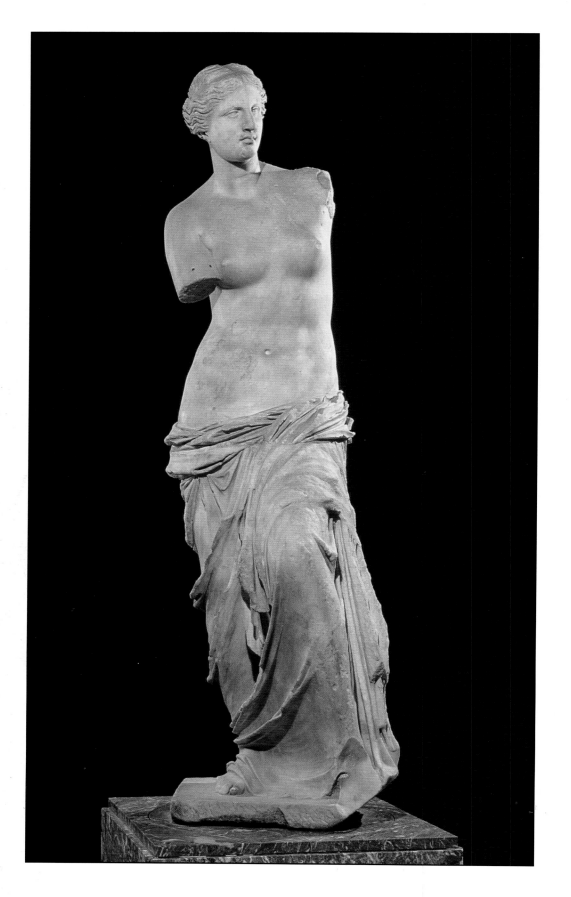

Venus de Milo
c. 150 B.C.; marble;
6 ft. 2 in. high (2.08 m).
Musée du Louvre, Paris.
Unlike Greek male forms
and the goddesses of other
contemporary societies, the
Greeks clothed their goddess
Aphrodite. It wasn't until
Praxiteles's fourth-century B.C.
Aphrodite of Cnidus that the
unclothed female form was
revived, inspiring centuries
of Hellenistic and Roman
nude goddesses, such as the
celebrated *Venus de Milo*.

**Equestrian Statue
of Marcus Aurelius**
A.D. 161–180; bronze;
*over life-size; Piazza del
Campidoglio, Rome.*
Marcus Aurelius is the
only surviving Roman
equestrian statue, a com-
mon form used to portray
important emperors and
generals. Although the
figure carries no weapons
or armor, the expression
on the face and position
of the body clearly show
the rider is victorious,
as does its over-large size
in proportion to the horse.

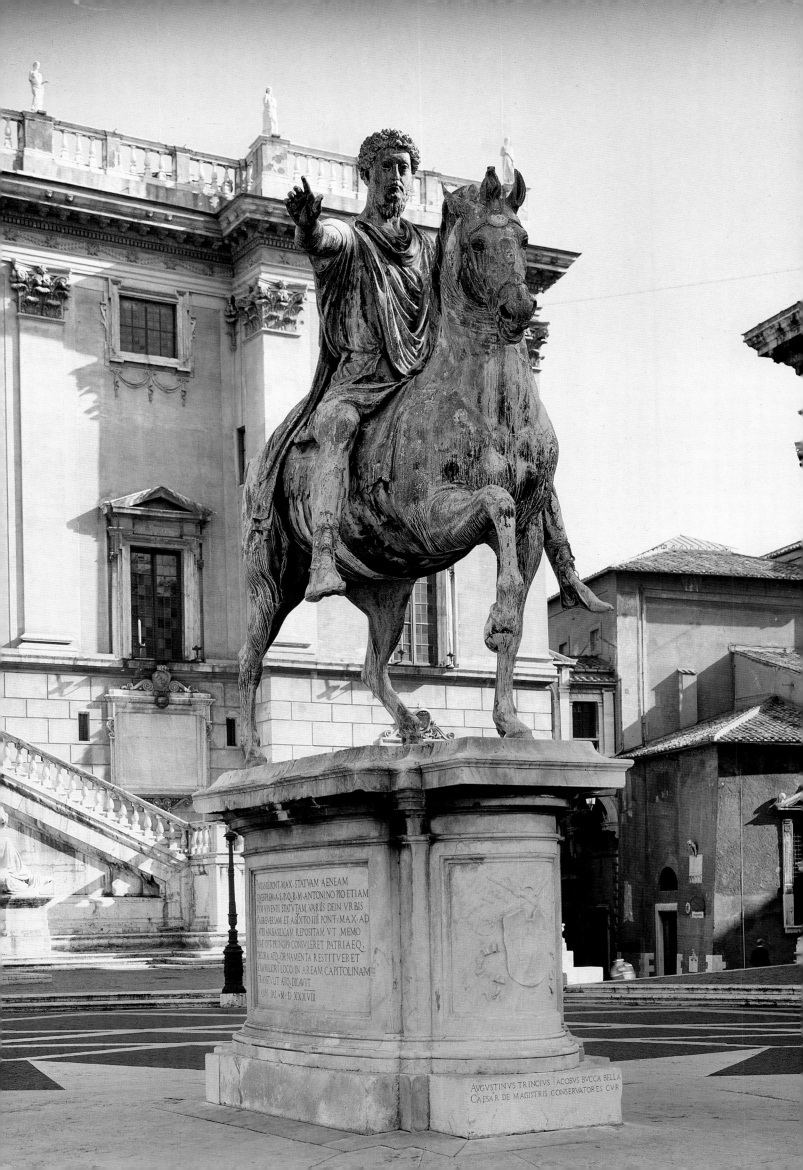

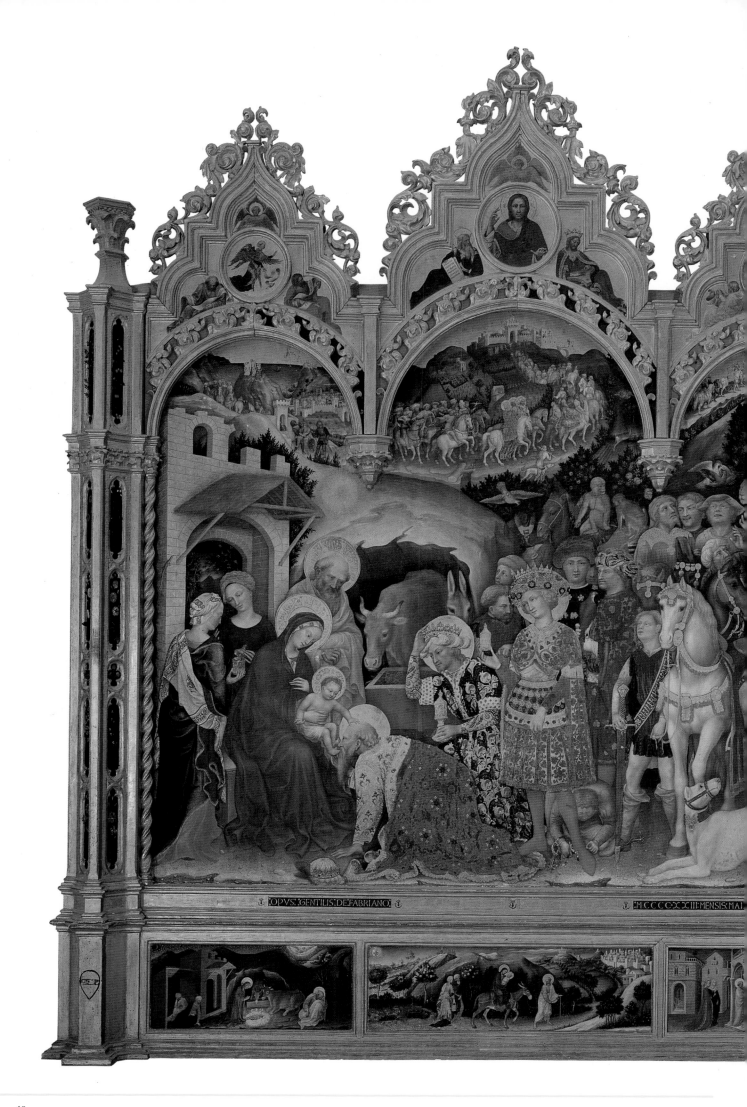

MEDIEVAL ART

Broadly defined, the middle ages (sometimes called the dark ages) refers to the thousand or so years between the end of the dominance of the Roman Empire and the revival of classical ideals that began with the Renaissance in fifteenth-century Italy. A Renaissance conceit, the concept of the dark ages typified the view that nothing of importance had been accomplished during this time, either in art or in other areas such as literature, philosophy, or science.

While it is true that in some ways civilization did not appear to progress and in fact seemed to reverse itself (in some regions, for example, the use of money disappeared and was replaced with the older tradition of barter), it is certainly inaccurate to say that nothing of value was accomplished during this period. The basic conventions and symbolism of Christian art, the intricate jewel-like miniatures of illustrated manuscripts, and the grand Gothic cathedrals of Paris and Reims all took shape during this era.

Art in Medieval Europe

With the shift of the center of the Roman Empire from Rome to Constantinople (present-day Istanbul in Turkey) in A.D. 330, the center of European culture moved north. Although Christianity had begun to evolve as a religion in the years following the death of Christ, it did not gain governmental acceptance until Constantine declared it, in the fourth century, the official religion of the Holy Roman Empire.

Just as early Buddhists had hesitated to depict the Buddha in human form, preferring symbols instead, so the early Christians adopted symbols for their new religion rather than portraying Christ directly as a human being. Part of the reluctance arose from the very doctrine that equated the Christ figure with that of the Christian God, while another obstruction was the commandment inherited from the Jews forbidding the making of graven images.

Nevertheless, by the fourth century Christian art with human figures does appear, mostly in frescoes adorning the walls of the underground tunnels of catacombs. In terms of style, the frescoes mirror those of the late Roman period, with modeled and foreshortened figures in classical clothing and postures. Classical Roman thought also provided many of the symbols of

The Adoration of the Magi
Gentile da Fabriano (c. 1370–1427); 1423; oil on panel;
9 ft. 10 in. x 9 ft. 3 in. (3 x 2.8 m). Galleria degli Uffizi, Florence.
Sinuous lines, jewel-like colors, and rich textures enhance Fabriano's
version of the story of the Magi, which begins in the miniatures under
each of the arches at the top and finishes with the throng in the center.
Although details are carefully rendered, there's little sense of depth.

**The Battle
of Hastings, from
the Bayeux Tapestry**

*c. 1073–83; wool embroidery
on linen; 240 ft. x 20 in.
(73 m x 50.7 cm).
Centre Guillaume le
Conquerant, Bayeux, France.*
Framed with an ornamental
strip of animals on the
top and fallen soldiers on
the bottom, this colorful
tapestry recounts the events
leading up to William the
Conqueror's invasion of
England in 1066. Tradition
holds that it is the work of
the court ladies of Mathilda,
the wife of William.

the new Christian art, such as grapes, which had been associated with the Roman god Bacchus and now came to represent the blood of Christ. Others, such as Christ as a lamb, were derived from Scripture, while still others followed a more esoteric path. Fish, for example, came to represent Christ because the initials of the phrase "Jesus Christ Son of God Savior" in Greek spell out the word for "fish" in Greek.

During the fifth and sixth centuries, much of Christian art took on conventions of the Near East and styles flowed out of Constantinople that were more flat, abstract, and symbolic than earlier Roman art. This trend continued until 726, when the Byzantine Emperor issued an edict banning all religious images. For more than one hundred years, only abstract patterns, such as the cross and floral arrangements, were permitted in Byzantine churches until the edict was reversed in 843.

Europe as a whole was changing greatly during this period, with waves of nomadic tribes from the north conquering already established areas and bringing their own artistic traditions with them. Large-scale art virtually disappeared but illustrated manuscripts thrived, often combining Christian conventions with those of the pagan, or non-Christian, invaders to create new abstract patterns and stylized animal forms, like those in the Irish *Book of Kells* in the early ninth century.

In addition to the Germanic and Celtic invasions from the north, the rise of Islam in the Near East led to Moslem invasions as far west as North Africa and Spain. Moslems took the prohibition against graven images from the Old Testament more to heart than either the Jews or the

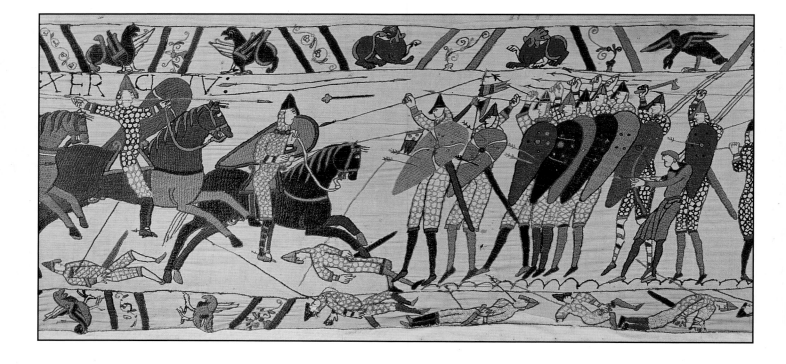

The Book of Kells
Early 9th century; vellum; 13 x 10 in. (33 x 25 cm). Trinity College Library, Dublin.
Irish monks combined Christian motifs and styles with pagan traditions to create a distinctly
Celtic form of illuminated manuscript. In addition to thirty-one full-page illustrations, the
Book of Kells features intricate patterns of interlaced bands, knots, and spirals throughout.

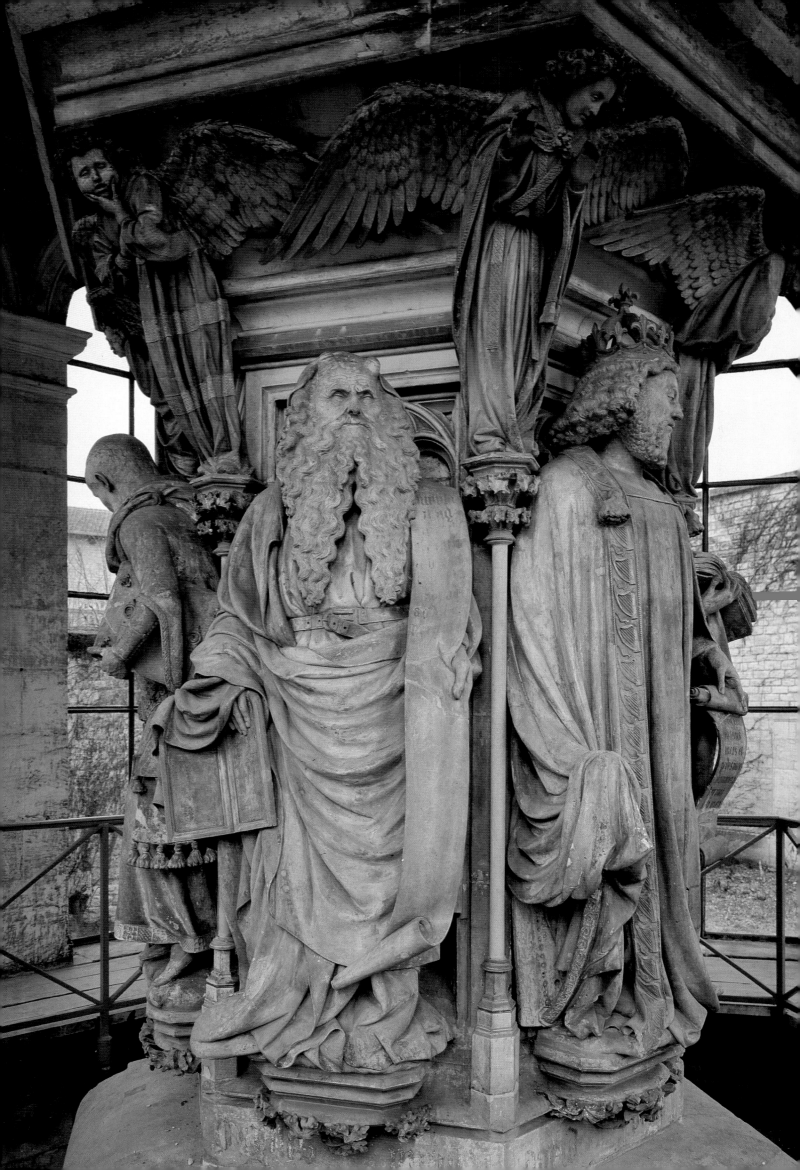

Christians of the time, and in the regions they conquered, all art representative of the human form was prohibited. As the early Christians had done before them and the eighth-century Byzantines were doing simultaneously, they took the prohibition to the extreme, destroying numerous existing works of art. Art did not die in the conquered lands, though; it was simply transformed into rich mosaic and tile decorations adorned with intricate geometrical shapes.

Meanwhile, in Northern Europe, the Germanic ruler Charlemagne attempted to restore the might of the Romans in the West with the creation of a new Holy Roman Empire in the late eighth century. At its height, the empire included present-day France, Germany, Belgium, the Netherlands, and parts of Italy, all united by their belief in Christianity. Charlemagne also actively encouraged the return to the classical Roman artistic ideals. Fusing such ideals with German and Celtic conventions as well as Byzantine concepts, artists developed a style of modeled and foreshortened figures characterized by an expressive religiosity.

As Christianity continued to grow, so did the need for churches that could accommodate larger numbers of worshippers. Again looking to the past, architects revived the heavy round arches, vaulting systems, and large interior spaces of Roman buildings to create massive Romanesque churches. With a large portion of the population illiterate, sculpture served to illustrate the stories of the Bible, and large-scale sculpture appeared on capitals of columns, on jambs and spaces around doorways, and especially on the tympanum, a large semicircular space above the entrance to the church.

The new style of sculpture, however, did not return to Roman ideals—the classical works were too calm and serene for the religious intensity of these Christians. Instead, artists returned to

The Annunciation and Visitation

West portal, Reims Cathedral; c. 1225–45.
Carved by at least three different sculptors, these figures show the evolution of the Gothic style. The two figures on the right imitate ancient Roman sculpture with classical poses and drapery, while Mary in the Annunciation (second from left) is clothed in much flatter, more severe drapery. The angel at left is a later addition, more elegant with a gentle sway.

The Moses Well

CLAUS SLUTER (c.1340–1406); 1395–1406; stone; c. 6 ft. high (figures) (1.8 m). Chartreuse de Champmol, Dijon, France.
In late medieval art, figures finally seem to detach themselves from columns and other architecture to become more like free-standing sculpture. Although the Old Testament prophets are still physically attached to this base, they have a weight and realism not seen since classical times.

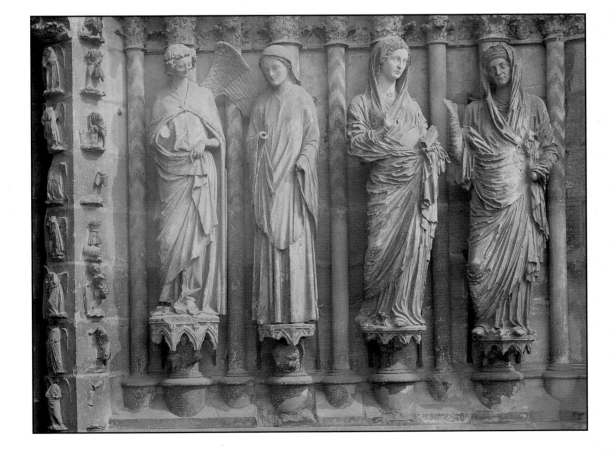

The Virgin of Paris
Early 14th century; stone;
Notre Dame, Paris.
By the Late Gothic, the
classic *contrapposto* and
drapery of earlier medieval
sculpture had evolved into
more ethereal forms. The
pronounced curvature and
swirling drapery make the
figure of Mary appear
almost to sway, heightening
its emotional appeal.

Kailasa Temple

Second half of 8th century;
volcanic rock. Photographs by
Phyllis Sternau. Ellora, India.
Ellora features some of the
finest medieval Hindu art.
Every available surface at
the mammoth rock-cut
complex portrays religious
figures in all positions—
meditating, dancing,
fighting, making love,
and grouped into narrative
stories. The temple is named
for Kailasa, the sacred moun-
tain range where Shiva lives.

Medieval Eastern Art

As in Europe, most of the major art innovations in medieval India, China, and Japan revolved around portraying religious images. In India, the huge Buddhist temple complexes that had been cut into rock from the first century A.D. continued to be excavated. Constructed to imitate the wooden architectural forms of the time, their stone walls were decorated with paintings using a frescolike technique. At Ajanta (seventh century), for example, sophisticated compositions with rich modeling evoke a sense of spirituality that is enhanced by the glow the figures seem to emit in the dark interior.

By the eleventh century, however, Buddhism in India had faded away completely, replaced by Hinduism, which had experienced a revival in the sixth century. The Hindus continued to excavate the same kind of rock-cut temples as the Buddhists, often sharing space during the centuries the two religions culturally overlapped. At the great monument Ellora, for example, twelve of the thirty-three caves are Buddhist, four are Jain, and the remainder are Hindu. Surrounded by a wall of rock that gives no indication of the splendors within, the huge complex is a testimony to the richness of medieval Indian art. In the massive courtyard, life-size elephants vie with intricately carved ornamental columns, stairways, and bridges, and relief images illustrating religious epics adorn every available space.

In addition to sculpture and paintings of gods and other important religious figures, many Hindu temples featured human couples in ecstatic embraces and positions of lovemaking. As the *Kama Sutra* demonstrates, the Hindu religion does not frown upon physical love as many Western religions do, although the exact function of the erotic temple carvings, which ceased in the thirteenth century, is not known. Reasons range from the idea that physical love between humans is a metaphor for union of the soul with the divine to speculation that orgiastic rites at one time actually took place within the temples.

When the Moslem invasions of northern India began around A.D. 1000, a cultural as well as a political split developed between the north and the south. In the north, Hindu architecture ceased and much of the existing Hindu art was destroyed. Painting, however, continued to thrive, especially in exquisite miniatures that incorporated the fine detail and complex coloring of Persian techniques.

In the south, however, sculpture continued to become even more elaborate, most notably during the Chola period from the ninth to twelfth centuries. Using the *ciré-perdu*, or "lost wax," casting method, sculptors created graceful figures in full movement. The dancing figure of Shiva as butter thief—a prank the god played in his youth—was very popular, as were depictions of Shiva Nataraja, the lord of dance form of Shiva who destroys and rebuilds the universe through his movements.

In contrast to the sculpture that was dominant in India, Chinese arts from the fourth century on centered around painting. Buddhism and its accompanying art flourished in China until A.D. 845, when Buddhism was banned and Confucianism was revived. Virtually no Chinese Buddhist art survives; however, Japanese arts of the time closely imitated Chinese. Fleshy Buddhas and bodhisattvas (enlightenment personified, popular Buddhist characters of legend) prevailed, broader and denser than those of India.

In addition to religious figures, Chinese art illustrated society's reverence for nature in landscapes. Landscape scenes became especially important during the Song Dynasty, which ruled from the tenth to the thirteenth centuries. Most common were monumental hanging scrolls in which the landscape was the dominant feature; if human figures were included they were very small. Fan K'uan, one of the master painters in the eleventh century, used a means of creating perspective that was unique to Chinese art in that no single point is used to draw the viewer into his paintings. Rather than focus on one point, the eye travels back and forth, taking in the entire surface.

In addition to the monumental style, several other styles evolved during the Song Dynasty. Emperor Hui Zong used the literal style, with precise and detailed representations of birds, animals, and plants, while Ma Yuan created asymmetrical landscape compositions with one corner empty. Mu Chi extended Ma Yuan's style to create intuitive and spontaneous studies that captured the essence of the subject in a few quick lines. His technique also took inspiration from calligraphy. While painters sometimes included calligraphy in scenes, calligraphy itself was considered an art form, the artistic quality of the brushstrokes as important as the story the words told.

Great Bodhisattva

Fresco; c. 600. Cave 1, Ajanta, India.
In Buddhism, the word "bodhisattva" refers to anyone destined for Buddhahood, although it most often refers to the historical Buddha before his enlightenment or the Buddha of the future. Here, the blue lotus flower in his hand identifies him as Avalokitesvara—the potential Buddha.

At the end of the thirteenth century, painting in China underwent a huge change stemming from Kublai Khan's invasion in 1279. Many painters chose exile rather than serve the new Mongol rulers, and their landscapes, previously distant and philosophical, became much more immediate and threatening as the artists reflected a new and much harsher world. After the Mongols were driven out in 1368, the indigenous Ming Dynasty ruled until 1644. For the most part, artists of the time revived the previous styles of the Song Dynasty, with minor variations such as touches of vivid color.

Although Chinese art had developed a singular style shortly after adopting the Buddhist images of the Indians, Japanese arts did not break with those of China and Korea until the Heian Period, at the end of the eighth century. During this time of great culture in Japan, with priorities centered around literature and the theater, a distinctly Japanese style in painting was fully developed by the end of the reign in the twelfth century.

The style is exemplified in a set of scrolls that illustrate the famous *Tale of Genji*, a complicated story of the intrigues of court life by Lady Murasaki. The artist Takayoshi has used the screens,

Shiva Nataraja
13th century; bronze; National Museum, Madras, India.
A Shiva Nataraja is always shown crushing a demon with one foot while the other is raised. Other traditions vary, such as the ring of flames sometimes shown to signify wisdom and energy.

Shiva Nataraja
Early 13th century; bronze; 34¼ in. high (87 cm). Nelson Gallery-Atkins Museum, Kansas City.
Shiva Nataraja—Shiva as God of the Dance— was one of the most popular Hindu images in Southern India during the Chola period from the ninth to the thirteenth centuries. By tradition, Shiva Nataraja always has at least four arms, one holding a drum to represent the creation of matter and another holding fire to signify the end of the universe.

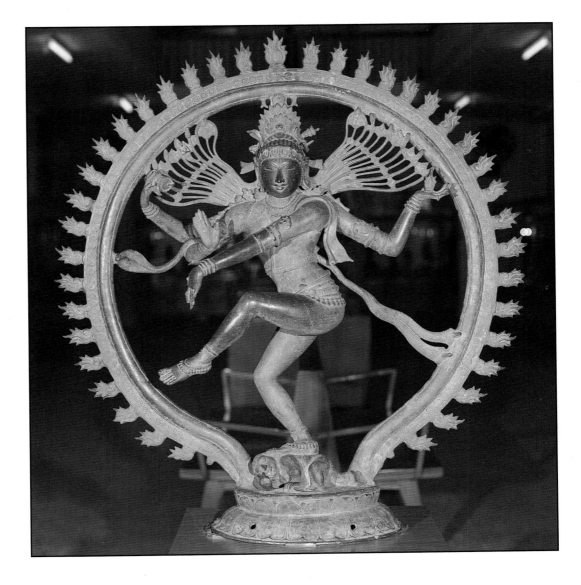

walls, and sliding panels of the houses to break up the composition but removed the roofs of the structures so the viewer can see the action inside. The picture plane is tilted with strong diagonal lines, simultaneously giving the scenes a two-dimensional feel and a sense of agitation. The faces of the characters appear like the Japanese masks used in theater, while the clothes and settings also recall the theater. Sprinkled asymmetrically with gold leaf, even the pages that depict only text display an artistic flair. Altogether, the style is wholly Japanese, completely different from artistic traditions anywhere else in the East or the West.

Simultaneously with this elegant court art, a more simple folk art developed, especially popular in the form of woodblock prints. Using the same kind of stylization and exaggerated action, the art was often humorous, illustrating flying houses from legends or rival religious factions in uncomplimentary ways.

After a period of civil war, though, the old court regime was perceived as decadent and art took on a new realism during the Kamakura Period, from the twelfth to the fourteenth centuries. Rebelling against the earlier stylization, artists created figures that were truly grotesque, such as the monster sculptures by Unkei which still stand guard outside the temple of Todaiji. Rising over 26 feet (8 m), the huge sculptures display exaggerated, tensed muscles and fierce expressions which were echoed in paintings of the time. Monster figures and torture scenes were popular images in painting, as was Fudo, a fanged guardian surrounded by flames. Interestingly, although Buddhism continued as a religion in Japan, these horrific religious images were among the last to be popularly depicted by artists, who then moved to focus more on secular scenes.

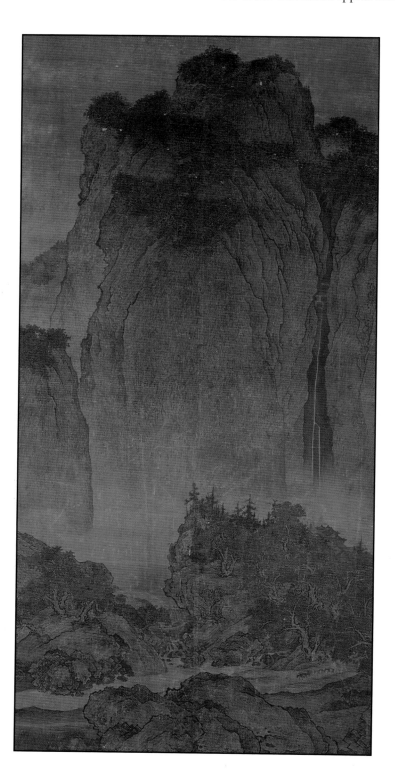

Travelers Amid Mountains and Streams

FAN K'UAN (active c. 990–1030); hanging scroll, ink on silk; 6 ft. 9 in. x 2 ft. 5 in. (2.06 x .73 m). National Palace Museum, Taibei, China.
To Chinese painters, humans were just one aspect of the glory of nature, as illustrated by the minute train of horses and people at the bottom of this work. Typical of Chinese landscape painting, this scene stresses no single focal point; the viewer's eye is meant to travel over the whole of the surface rather than be drawn to one area of it.

A Solitary Temple Amid Clearing Peaks
LI CHENG; c. A.D. 950;
ink and color on silk;
44 x 22 in. (111 x 60 cm).
Nelson Gallery-Atkins Museum, Kansas City.
In contrast to the public Buddhist art, landscape painting in China has always been of a more private nature, practiced by the artist-scholar typified by Li Cheng, a well-educated man of good family. The goal of his type of landscape was to try to approximate the essence of nature, as opposed to a faithful recording of a scene.

Late Gothic and Renaissance Art in Northern Europe

Although no one event marks its beginning, a new style of art emerged in the early fifteenth century, both in Italy and in the northern European lands, mostly present-day Holland and Belgium, and especially in the city of Flanders. In Italy the changes heralded the Renaissance, a deliberate effort to make a break from the preceding middle ages and to return to the perceived noble concepts of classical antiquity. In the North, however, while the change was just as radical, it was not as consciously developed. Instead of actively rejecting the earlier International Style, artists used it as a starting point for further development. This period in the northern countries is sometimes referred to as the Northern Renaissance for the changes that led to new beginnings; it is also termed the Late Gothic because of its lack of a clear break with the preceding era.

Mérode Altarpiece
*The Master of Flémalle
(ROBERT CAMPIN);
c. 1425–30;
oil on wood panels;
center 25³/₈ x 24⁷/₈ in.
(64.3 x 62.9 cm),
each wing 25³/₈ x 10⁷/₈ in.
(64.3 x 27.5 cm).
The Metropolitan
Museum of Art, Cloisters
Collection, New York.*
For the first time, the secular and the spiritual are merged in this Annunciation scene which takes place in a contemporary home. Many of the details are symbolic, such as the towels that represent the purity of Mary; others are more obscure to modern viewers, like the mousetrap on Joseph's workbench.

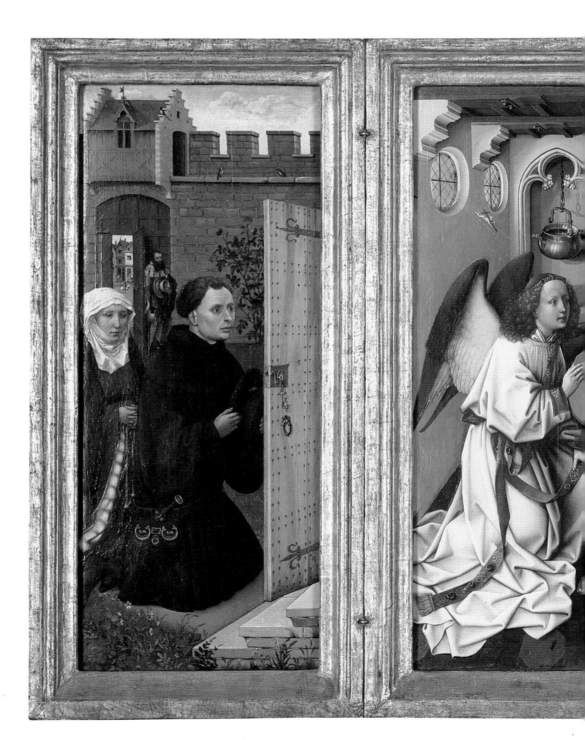

In either case, the changes wrought in painting were powerful and affected the art of Italy long before Italian concepts moved north to impact on the Northern artists. On the other hand, sculpture and architecture in the Northern lands remained essentially stagnant, mired in the flamboyant Gothic mode despite changes in Italy.

During this time of transition in the North, the hallmarks of the International Style in painting—rich color and a fondness for pattern and detail—continued. Around 1420, however, artists started to realize the potential of using oil glazes. More slow-drying than fresco or tempera, oil painting allowed artists a much more exact representation of light and color as well as the ability to create finer details, which together produced more realistic effects than previously possible.

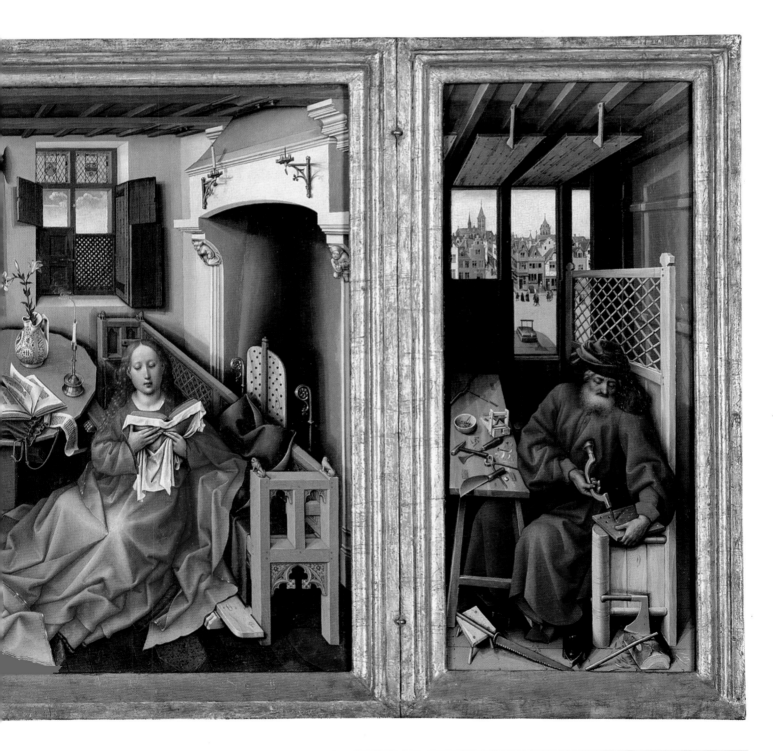

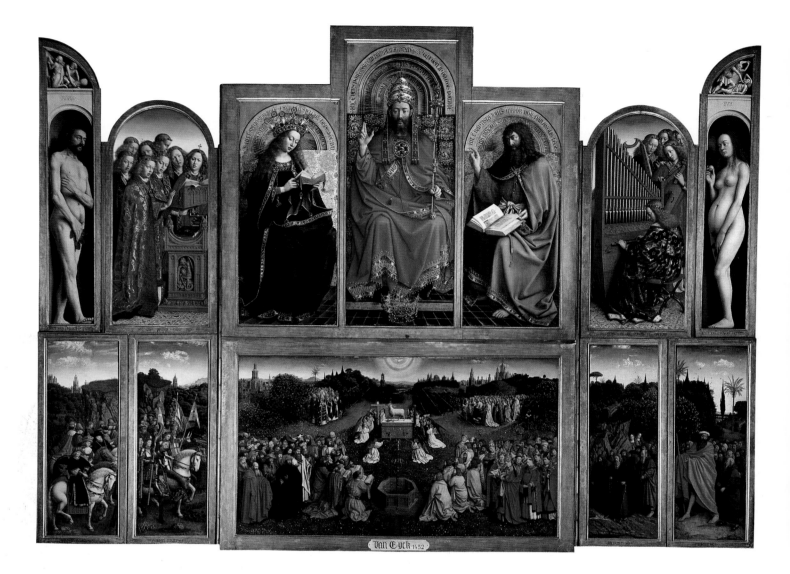

The Ghent Altarpiece

HUBERT (c. 1370–1426)
and JAN (c. 1390–1441) VAN
EYCK; c. 1425–32; oil on panel;
11 ft. 3 in. x 14 ft. 5 in.
(3.4 x 4.4 m). Church of
St. Bavo, Ghent.

Begun by Hubert van Eyck
and finished by his brother
Jan, this altarpiece is one
of the finest examples of the
detail that could be created
with oil paint. The piece
is also notable for its large-
scale Adam and Eve, the
first nudes of this size in
Northern panel painting.

One of the first to experiment with oil painting on panels was a man today known only as the Master of Flémalle, after the remnants of a large altar attributed to him in Flémalle, near Liège. While none of his works are signed or dated, they all fit the known data of an artist named Robert Campin, leading many scholars to declare that the two are one and the same. Regardless of his identity, the painter made major contributions to the new developments in northern Europe in the first part of the fifteenth century.

Building on the spiritual emphasis of the middle ages, the Master of Flémalle married the spiritual to the everyday, placing religious events in contemporary settings and giving the physical world a symbolic significance not previously portrayed. He was the first, for example, to paint a scene (in the Mérode Altarpiece) of the Annunciation taking place in a contemporary domestic setting. The minutiae so painstakingly recreated serve a dual purpose, both to provide the household atmosphere and to symbolically represent the concept of spirituality in common items, so that the vase of lilies appears not only as a pretty decoration but as an image that signifies the chastity of Mary.

Painting at around the same time, Jan van Eyck was the first Flemish painter to sign his works and is considered the master of the Netherlandish school of painting. Van Eyck was the first artist to truly exploit the full potential of painting with oils, applying the oil paint in superimposed translucent layers to achieve the rich glowing colors that became a trademark of the period and faithfully reproducing minute details, rich textures, and subtle variations in light. While the

Italians were working out the rules of linear perspective, which applies the principle that objects tend to look smaller as they get farther from the viewer, van Eyck was perfecting a more intuitive approach to atmospheric perspective, in which gradations in tone and color suggest distance.

A third great painter of this period, Rogier van der Weyden, focused more on the emotional makeup of his subjects rather than on realistic detail, as did the Master of Flémalle and van Eyck. For most of the rest of the century, artists continued in the same manner as these three masters, with variations according to individual temperament. Hugo van der Goes, for example, combined the intense emotion of van der Weyden with van Eyck's attention to detail in religious scenes that take place against contemporary backgrounds, while Petrus Christus painted quiet religious portraits. The art of the North expanded to other countries, influencing such artists as Konrad Witz in Switzerland and Jean Fouquet in France.

In the beginning of the sixteenth century, the innovations of the Italian Renaissance had moved out of localized centers to affect artists throughout Europe. In Germany, a center for Gutenberg's fifteenth-century invention of movable type as well as woodcuts and engravings, Albrecht Dürer thrived as both a painter and an engraver. Two trips to Italy so

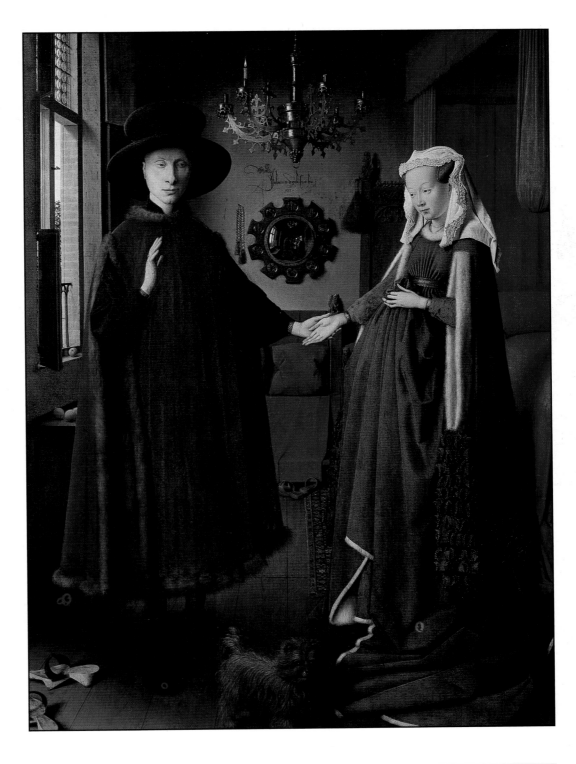

Wedding Portrait

JAN VAN EYCK (c. 1390–1441); 1434; oil on panel; 33 x 22½ in. (83.7 x 57 cm). The National Gallery, London. An apparently straightforward domestic scene, this painting is rich in the symbolic detail that characterized van Eyck's work. For exaple, even though it is day, one candle burns in the chandelier, symbolizing either the marriage candle typically lit in the home of newlyweds or the eternal and all-seeing nature of Christ.

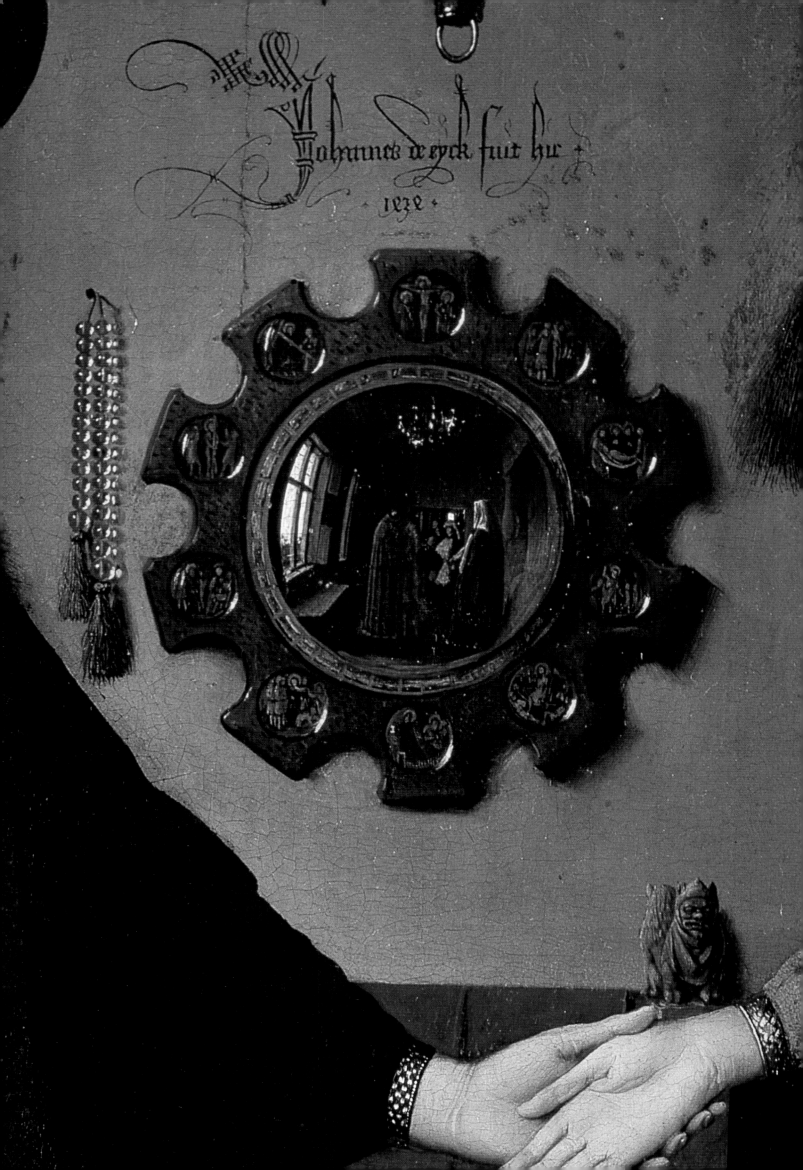

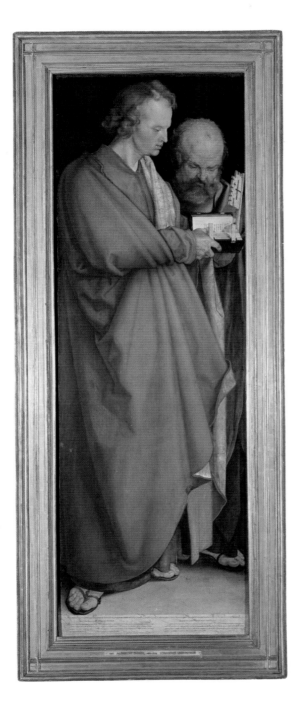

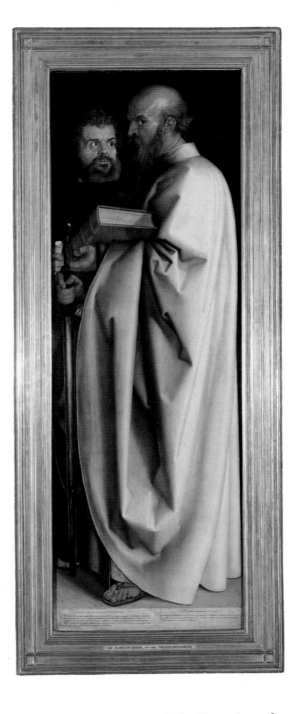

Mirror, from *Wedding Portrait*

detail; JAN VAN EYCK (c. 1390–1441); 1434;
oil on panel. The National Gallery, London.
Although the couple is apparently alone in the
room, a close look at the mirror reveals two
other people watching them. One is presumably
the artist, who signed the painting above the
mirror: "Jan van Eyck was here in the year 1434."

The Four Apostles

ALBRECT DÜRER (1471–1528); 1523–26;
oil on panels; each panel 85 x 30 in.
(216 x 76.2 cm). Alte Pinakothek, Munich.
An admirer of Martin Luther, Dürer presented
this work to the city council of Nuremberg
after the city accepted Lutheranism. The
panels are clearly Protestant in their depiction
of the saints: John in front of Peter on the
left, and Paul in front of Mark on the right.

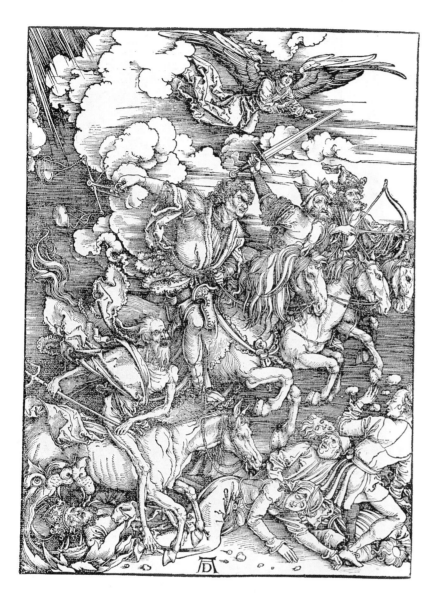

The Four Horsemen of the Apocalypse

ALBRECHT DÜRER (1471–1528); c. 1497–98; woodcut; 15½ x 11⅛ in. (39.3 x 28.3 cm).
The best known of a series of fourteen woodcuts that illustrate the biblical Apocalypse, this example portrays the still-strong Gothic conception of the Last Judgment. It was produced before Dürer's second trip to Italy and shows the energy of tightly packed, interwoven forms that would later evolve into larger, calmer constructs.

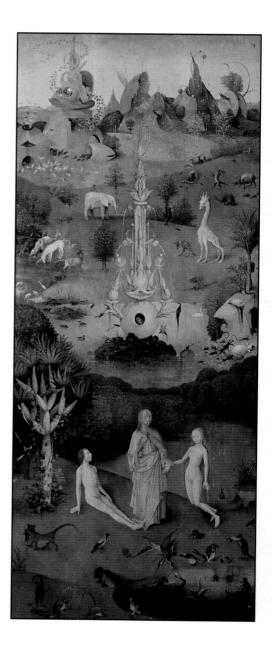

The Garden of Earthly Delights

HIERONYMUS BOSCH (c.1450–1516); c. 1510–15; oil on panel; center 86½ x 76¾ in. (219.7 x 195 cm), wings each 86½ x 38 in. (219.7 x 96.6 cm). Museo del Prado, Madrid.
This renowned work is filled with minute symbolic detail: the left panel represents the creation of Adam and Eve; the center shows life on earth as a continuous process of sinning; and the right depicts an eternal hell. The otherworldliness arises not from the strange creatures representative of medieval works but from ordinary beings depicted in bizarre and imaginary ways.

impressed him that he aspired to bring the latest developments to his country. Because prints could be reproduced so quickly and circulated widely, Dürer's work was publicly available and inspired numerous other artists. Dürer was also a proponent of the then-new religion conceived by Martin Luther, Protestantism, which would color his art as it did that of later German artists, including Lucas Cranach the Elder. Others, such as Hans Holbein the Younger, continued Dürer's tradition of portrait-making.

In sixteenth-century Netherlands, where so much of the great art of the fifteenth century had its genesis, innovations were not as rapid or all-consuming. Hieronymus Bosch, who was working at roughly the same time as Dürer, stands out for being completely removed from the concepts of humanism and Classicism that informed so much of Dürer's work as well as from other precepts of the Italian Renaissance. Bosch's art is difficult to understand on its own, a

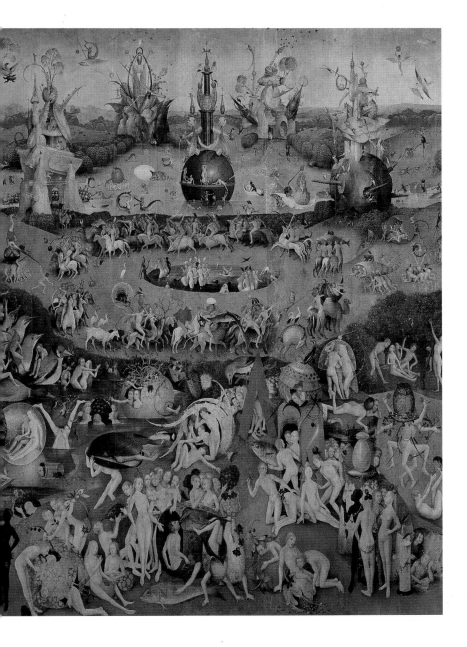
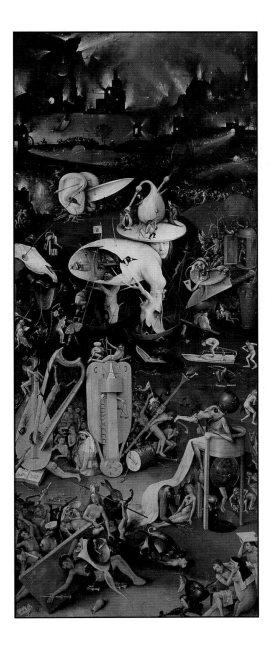

situation made more complex because little is known of the artist's background or history. His best-known work, *The Garden of Earthly Delights*, is clearly a commentary on society, but exactly what that comment conveys is open to interpretation. Like the works of the earlier masters, the painting is filled with symbolism, but here the realistic details combine in bizarre ways to form a completely preternatural landscape of a kind that would not be seen again until the visions of the twentieth-century Surrealists.

Influenced by Bosch, Pieter Bruegel the Elder, arguably the greatest sixteenth-century Flemish artist, began his career with strange moralizing paintings. Although Bruegel had traveled to Italy and used the aerial perspective he learned there, he never adopted their idealized subject matter. Instead, his paintings depict everyday events in the lives of peasants as well as biblical parables and landscapes, all executed with attention to minute detail and an appreciation for both the serious and comic sides of life.

The Blind Leading the Blind

PIETER BRUEGEL THE ELDER (c. 1525–69); c. 1568; oil on panel; 34½ x 60⅝ in. (85 x 154 cm). Museo di Campodimonte, Naples. Illustrating the biblical line of Christ "And if the blind lead the blind, both shall fall into a ditch," the moralizing tone of this painting is clear but, in light of the little that is known of the artist's politics or religion, the exact nature of the moral is open to interpretation.

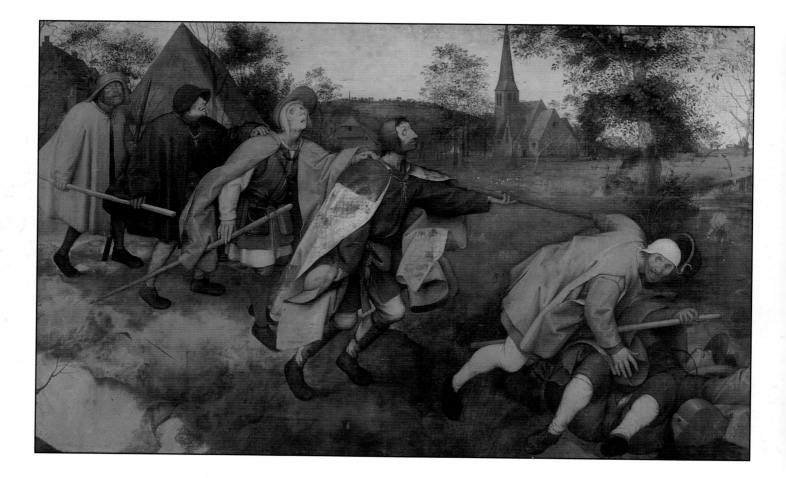

Egg, from *The Garden of Earthly Delights*

detail; HIERONYMUS BOSCH (c.1450–1516); c. 1510–15; oil on panel. Museo del Prado, Madrid. Within the microcosm of a cracked egg, humans appear to be damned from their very conception, unable even to find salvation in traditional Renaissance symbols of hope. Religion, as shown by the despairing nun in the egg, cannot save one any more than can intellect, portrayed as an exercise in futility with the knife piercing the empty space between two ears.

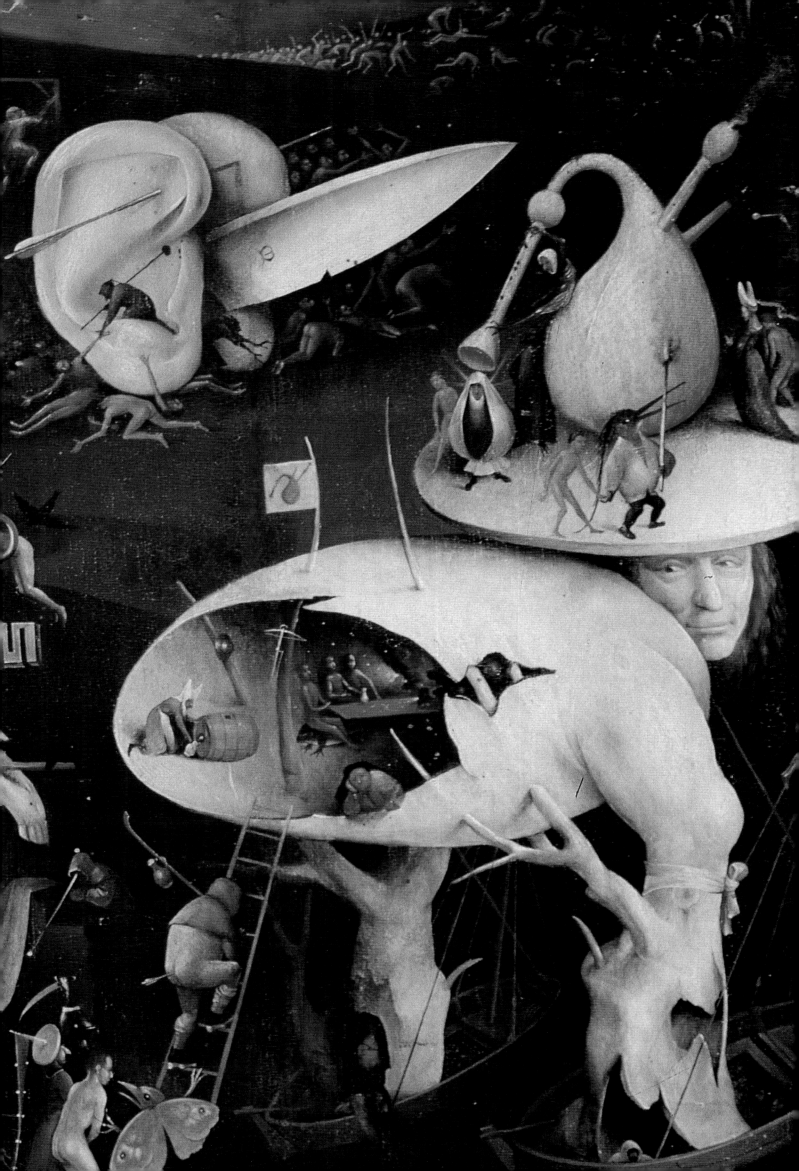

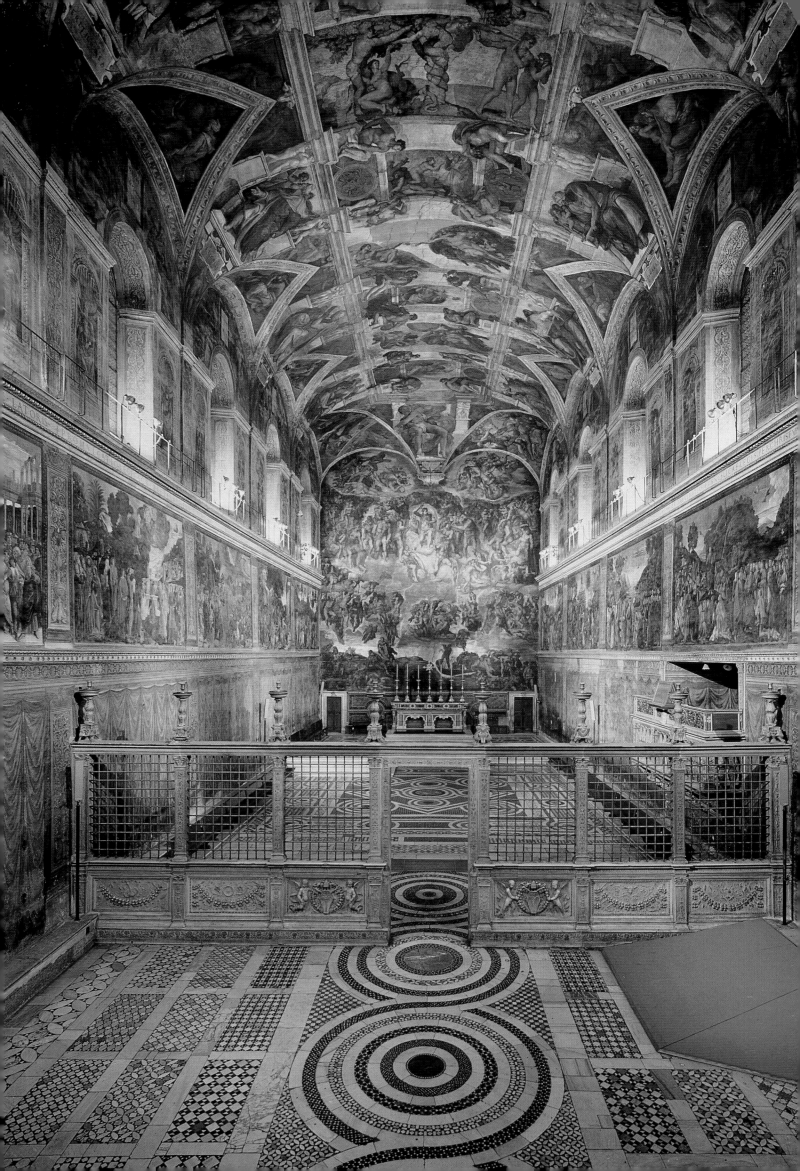

THE RENAISSANCE

The International Gothic style that flourished in the northern parts of Europe never gained as strong a footing in Italy. In Florence, especially, a radically new spirit was emerging. A wealthy city-republic, Florence was renowned for its traditions of liberty, political savvy, and superior crafts. Under the leadership of the Medici family in the fifteenth century, the city thrived. Florentines took to comparing themselves to the ancient Greeks and considered their city to be the "new Athens."

The look back to the ancients as the supreme ideal had actually started a century earlier when the Italian poet and Latin scholar Petrarch rejected the period after the Romans as one of "darkness" and revived the study of classical learning. Classical heritage had, of course, never completely disappeared during the middle ages, but it was not until the fourteenth century that scholars found a way to combine the merits of ancient secular values and philosophies with those of Christian thought. Called Humanism, this new belief in the worth of human achievements through history, whether Christian or otherwise, led to a "rebirth" in literature, philosophy, and art—the Renaissance.

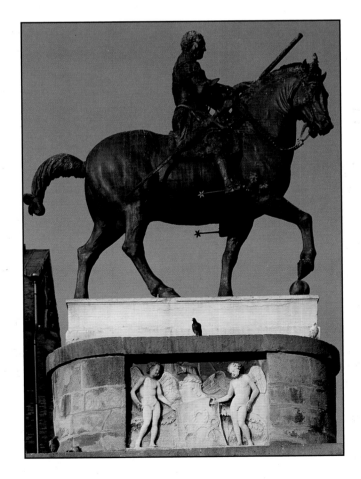

Sistine Chapel
MICHELANGELO (1475–1564);
1508–1512; fresco.
The Vatican, Rome.
It took Michelangelo four years to paint the ceiling of the Sistine Chapel, for the most part working without assistants. Nine main scenes from the Book of Genesis are peopled with expressive, realistic figures in dynamic motion while architectural forms, biblical prophets, mythological prophetesses, and nude male youths form a background teeming with action.

Equestrian Monument of Gattamelata
DONATELLO (1386–1466);
1445–50; bronze;
11 x 13 ft. (3.35 x 3.96 m).
Piazza del Santo, Padua.
Donatello was the first Renaissance sculptor to revive the ancient bronze equestrian statue, inspired by the Roman statue of Marcus Aurelius. Although the two are similar, subtle differences can be seen in the position and proportion of the rider, as well as other details.

The Renaissance in Italy

Although the Renaissance was foreshadowed in art as early as the fourteenth century when Giotto introduced new concepts of drama and monumentality set into a stagelike space in his paintings, it was not until the fifteenth-century's ambitious building program in Florence that the ideals truly started to take shape. The first major developments were in architecture, when Filippo Brunelleschi studied ancient buildings to devise a plan for the dome of the Florence Cathedral, a project of such grand scale that previously it had been impossible to complete.

Greco-Roman reliefs, the most prevalent and visible remnants of the ancients, had already been inspiring Gothic artists. Now, though, Donatello combined a careful study of the human

The Tribute Money
*MASACCIO (1401–28?);
c. 1427; fresco; 8 ft. 4 in. x
19 ft. 8 in. (2.54 x 5.9 m).
Brancacci Chapel, Santa Maria
del Carmine, Florence.*
The first great painter of
the Renaissance, Masaccio
used linear perspective and
a strong interplay of light
and shadow to tell a story
from the Gospel of Matthew,
taking into account that the
viewer would be standing
14 feet (4.3 m) below the
painting when it was in place.

Bacchanal
*TITIAN (1490–1576); c. 1518;
oil on canvas; 5 ft. 8⅞ in.
x 6 ft. 4 in. (1.7 x 1.9 m).
Museo del Prado, Madrid.*
A dramatic and original
colorist, Titian is considered
the first painter of the
Renaissance to fully explore
the rich potentials of oil
paint. Although many of
his paintings centered around
classical themes, his figures
are active and muscular
individuals and not simply
idealized gods and goddesses.

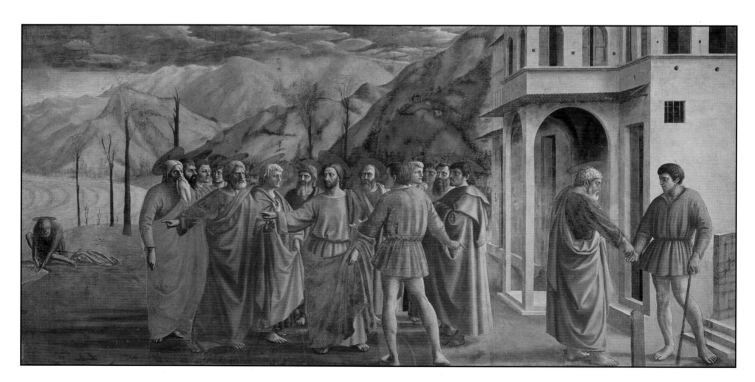

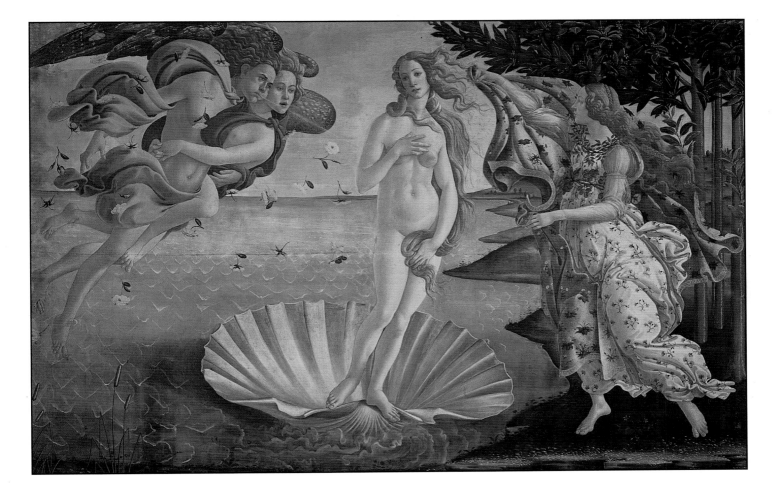

form with the techniques of the ancients and was one of the first sculptors to realistically approximate their essence. In his revival of classical forms, such as the large free-standing nude *David*, Donatello created weighty figures in the realistic *contrapposto* stance. When clothed, his figures were conceived as "clothed nudes" so that the drapery fell realistically over a body instead of taking the place of the form underneath. Donatello was also the first to revive the equestrian statues that had been so popular in ancient Rome.

Taking inspiration from Brunelleschi's architecture, Donatello's sculpture, and the earlier achievements in painting by Giotto, Masaccio applied the principles of linear perspective to his paintings. Painters in the north were already making great strides in creating a realistic illusion of space with the careful application of color, but Masaccio achieved similar effects through line. The concept, which would be used through the rest of the century, imagined the picture surface as an open window through which the world is seen. Masaccio used receding parallel lines to connect the spectator's eye to a spot in the distance called the vanishing point. With this method, the artist could establish and control the way viewers observed a painting.

In addition to affecting the methods that artists used, this new look at the past opened up numerous new subject possibilities. The vast majority of medieval art had been Christian-oriented. In northern Europe, religious subjects still prevailed, although often placed into contemporary settings. With the advent of Humanism, an even more liberal concept of Neo-Platonism evolved that embraced the idea that all human thought, whether Christian or pagan,

The Birth of Venus

*SANDRO BOTTICELLI
(c. 1445–1510); c. 1480; tempera on canvas; 5 ft. 8⅞ in.
by 9 ft. 1⅞ in. (1.8 x 2.8 m).
Galleria degli Uffizi, Florence.*
With the new concept of Humanism and a revived interest in the ancient ideals of beauty, subjects from ancient mythology enjoyed a resurgence during the Renaissance. Botticelli combined the Classical Roman pose of antique statues with the more recent Gothic sway to create a sensual, elegant, and ethereal embodiment of the goddess of love.

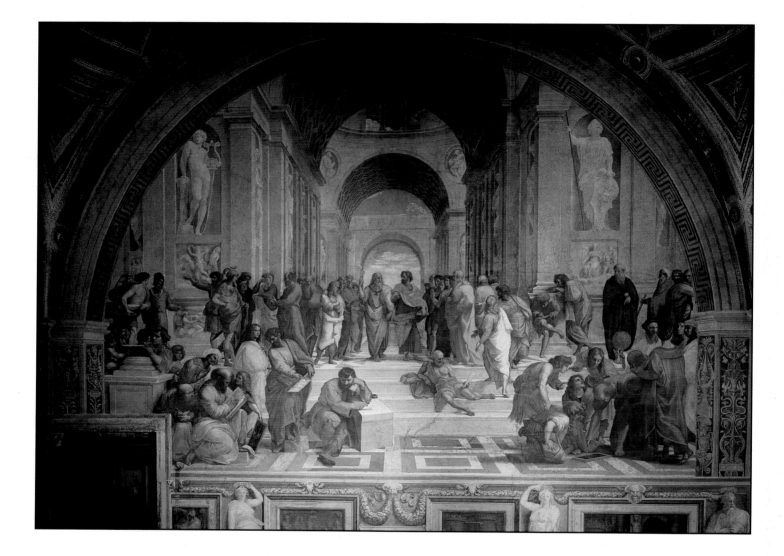

The School of Athens

RAPHAEL (1483–1520);
1510–11; fresco. Stanza della
Segnatura, Vatican Palace, Rome.
Numerous ancient philoso-
phers are grouped within
the deep architectural
perspective of this work,
creating the impression of
vast space with interdepen-
dent groupings. In the
center, Plato points up to his
source of ideas while Aristo-
tle points down to the earth,
with the arch behind the
two forming a sort of halo.

was divinely inspired. It was this openness that allowed artists such as Sandro Botticelli to paint the gods and goddesses of mythology with the same seriousness and spirituality typically reserved for Christian images.

As the Renaissance took firm hold, its center moved from Florence to Rome, where the Catholic Church was spearheading a building blitz at the beginning of the sixteenth century. The ideals of the Renaissance also underwent a subtle shift. By this time, the fifteenth-century inno-vations concerning proportion, *contrapposto*, and linear perspective were now well established. Artists sought new ways to express themselves, leading to what is called the High Renaissance, a shockingly brief period from about 1500 to 1520 when artists such as Leonardo da Vinci, Michelangelo, and Raphael produced some of the most extraordinary works of art of all time.

Leonardo, the eldest of the men, truly embodies the essence of the expression "Renaissance man." Not only was he a painter, sculptor, and architect, but he was extremely learned in a daz-zlingly eclectic array of fields, from anatomy to music to optics. With such a range of interests and skills, it is not surprising that many of his works never saw fruition. His numerous note-books, written in reverse "mirror" writing, feature designs for flying machines, ball-bearing mechanisms, cannons, and other inventions that would not materialize for hundreds of years.

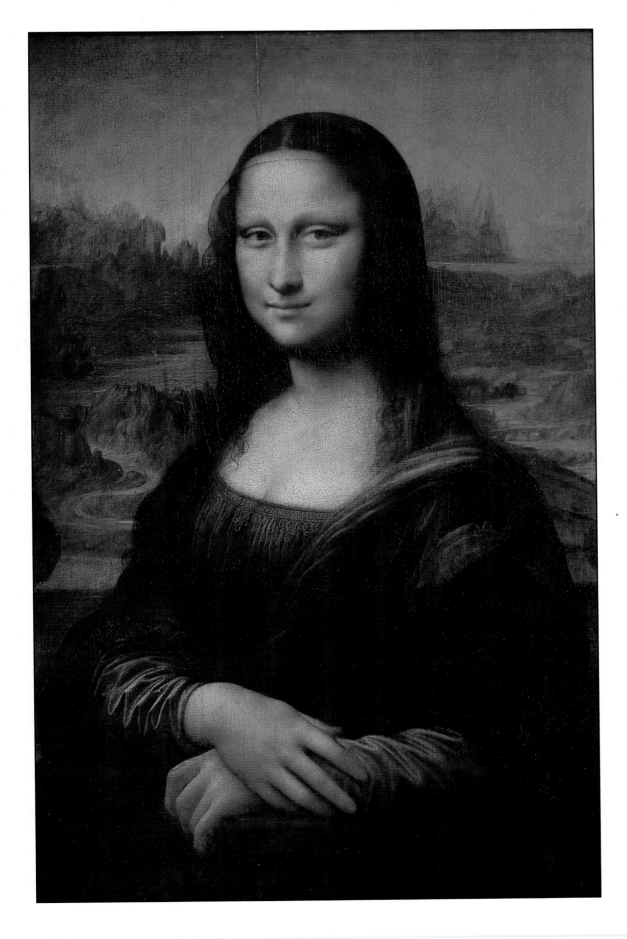

Mona Lisa
*LEONARDO DA VINCI
(1452–1519);
c. 1503–05; oil on
panel; 30¼ x 21 in.
(77 x 53.5 cm). Museé
du Louvre, Paris.*
Created with ex-
tremely thin layers
of glazes, the painting
seems to glow with
a light from within.
The haunting moun-
tain landscape in the
background echoes
the mysterious smile
that touches just the
corners of the *Mona
Lisa*'s eyes and mouth.

FOLLOWING PAGE:
**The Creation
of Adam**
*detail from the ceiling
of the Sistine Chapel;
MICHELANGELO
(1475–1564);
1508–1512; fresco.
The Vatican, Rome.*
Every part of Adam's
body strains toward
God, a stern father
figure who extends
his finger in the act
of creation. Eve, not
yet created on earth,
remains with the
angels in the crook
of God's arm.

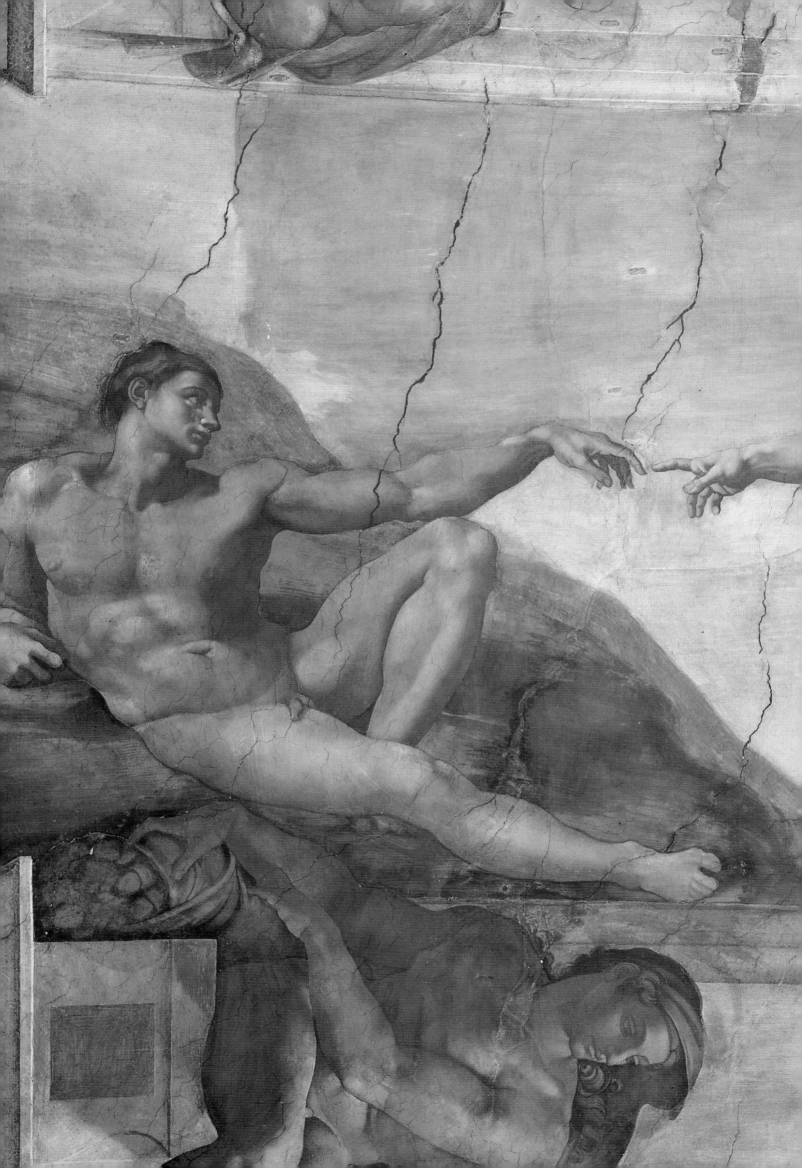

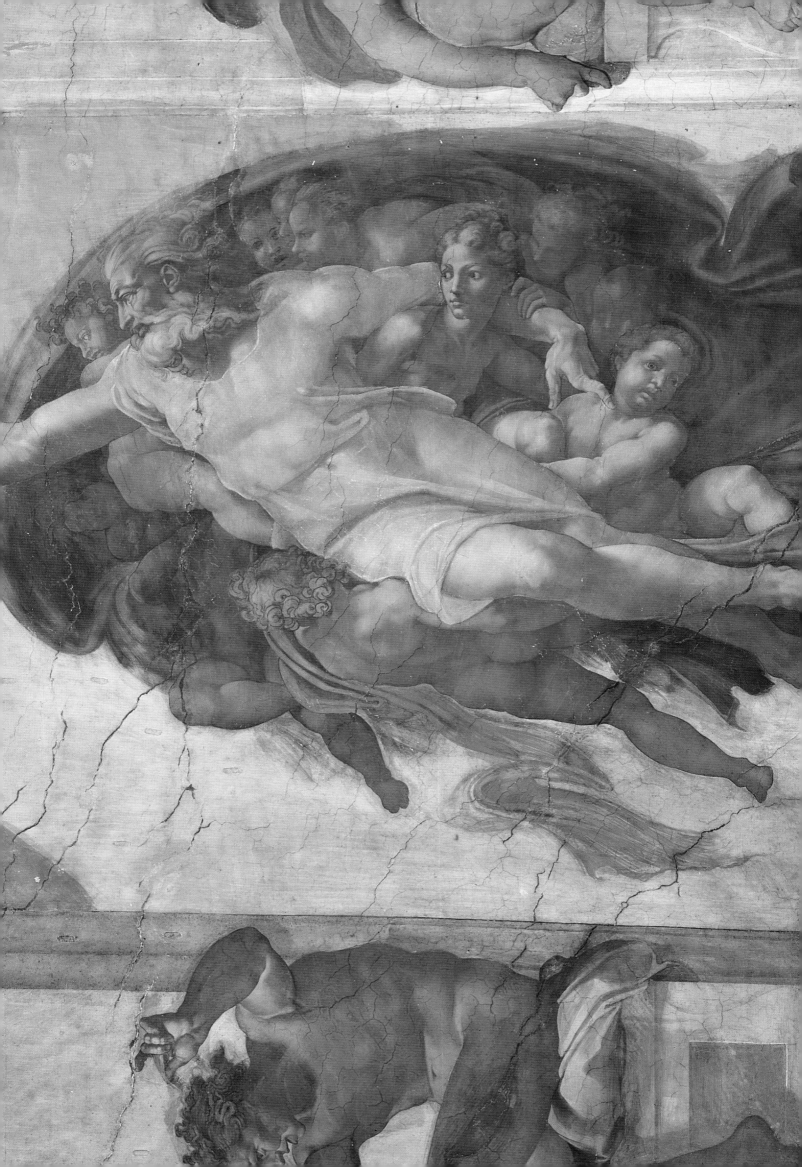

There are sketches for buildings never constructed, models and casts never completed, theories never published.

What he did achieve, however, affected artists for centuries to come. Instead of defining figures by first drawing their linear boundaries, he used a process called *chiaroscuro*, working with lights and darks alone to give definition and solidarity to his forms. For his best-known work, the *Mona Lisa*, he employed a variation on the theme, *sfumato*, which literally means "up in smoke" and is a very subtle form of *chiaroscuro* in which outlines are softened and shadows blurred to create a misty blending of colors.

Like Leonardo, Michelangelo excelled in a variety of fields and his *oeuvre* includes masterpieces in all the primary media: the architectural splendor of St. Peter's, which he oversaw after the death of Donato Bramante; his sculpture *David*, the first colossal nude since antiquity; and, of course, the fresco on the Sistine Chapel, painted almost single-handedly over a period of four years. In both painting and sculpture, his works are marked by an attention to musculature and detail that produced graceful motion in his extremely expressive figures.

At the same time that Michelangelo was completing the Sistine Chapel, Raphael was also working in the Vatican, on his *School of Athens*. It is likely that the Sistine Chapel ceiling influenced Raphael's work, which has a similar sense of expressive energy and physical power within the figures. Yet the poses and gestures are Raphael's own, not mere imitations of Michelangelo. In the same way, Raphael learned from Leonardo, and his composition and groupings echo Leonardo's *Last Supper*, although set in a completely different framework.

In Venice—part of Italy but different from the rest of the country in terms of political, economical, and philosophical mores—Renaissance artists took a slightly different path. The best known of the artists there, Tiziano Vecellio, known as Titian, is especially renowned for the rich and sensual effects he achieved through the use of color with oil paints and the dynamism of his brushstrokes. Titian portrayed both Christian and mythological scenes in more than four hundred paintings spanning a career of over seventy years.

The Last Supper

LEONARDO DA VINCI
(1452–1519); c. 1495–98;
mural painting; 15 ft.
1⅛ in. x 28 ft. 10½ in.
(4.6 x 8.56 m). Santa Maria
delle Grazie, Milan.
Leonardo's experiments with composition—placing Judas on the same side of the table as Christ and using the window to form a halo for Christ—were a success that inspired later artists. However, his technical innovation of painting on the dry wall with a mixture of oil paint and tempera failed; the painting started to deteriorate shortly after its completion.

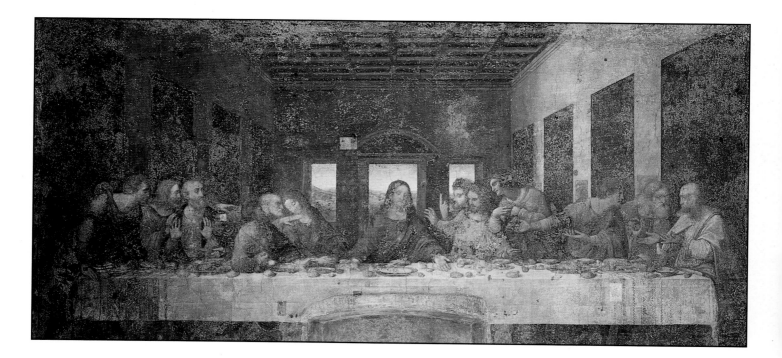

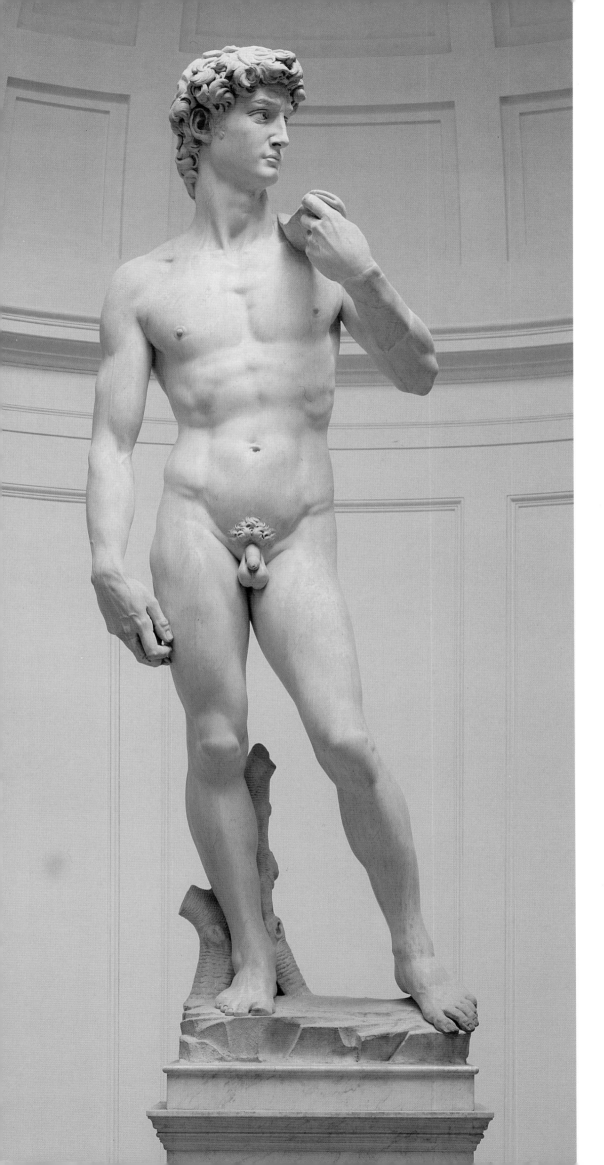

David

*MICHELANGELO
(1475–1564); 1501–04;
marble; 13 ft. 5 in. high
(4.08 m). Galleria
dell'Accademia, Florence.*
When placed in a public
square in the Renaissance
era, *David* was the largest
free-standing marble that
had been created since
classical times. With his
noble, idealized head and
athletic, finely muscled
body, this work was seen
as a symbol of Florence's
cultural supremacy.

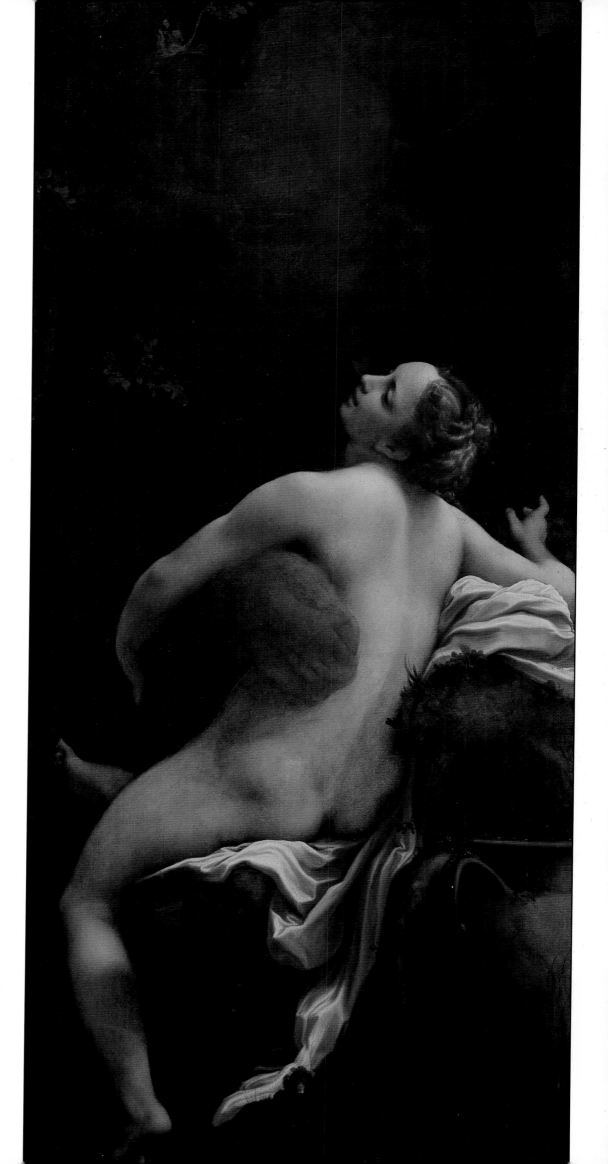

Jupiter and Io

CORREGGIO
(1489/94–1534);
c. 1532; oil on canvas;
64¹/₂ x 27³/₄ in.
(163.8 x 70.5 cm).
Kunsthistorisches
Museum, Vienna.
For the Duke of
Mantua, Correggio
painted a series that
recounted the various
loves of Jupiter as he
disguised himself to
hide his affairs from
Juno. Here, Jupiter
appears as a vaporous
cloud that engulfs the
voluptuous nymph Io in
a rapturous embrace.

Mannerism

During the period of the High Renaissance, the works of artists such as Michelangelo and Raphael were considered by their contemporaries to epitomize the perfect *maniera*, or style. How then could younger artists improve upon this seeming perfection? A dominant trend among several evolved under the name of Mannerism. Loosely defined, Mannerism is simply the period from the 1520s and the gradual end of the High Renaissance to the beginning of the seventeenth century, when the Baroque style came into vogue.

In some ways a natural outgrowth of the Renaissance while in others a rejection of Renaissance styles, Mannerism became the deliberate cultivation of *maniera*, often to an extreme that was considered affected. Classical figures became elongated, colors took on a harsher tone, compositions veered to the asymmetrical and agitated. With its emphasis on dexterous skill and form over subject, Mannerism by the seventeenth century came to have a negative connotation that would last into the twentieth century. Critics claimed that the demonstrations of technical skill produced works that were cold, calculated, and unnatural.

There is no question that Mannerist works were carefully planned and designed to show off the technical dexterity of the artist. Compositions are surely unnatural and sometimes even downright bizarre. Yet many of the same works include a wealth of detail and symbolic meaning that, if elusive, lend a mystical and emotional quality that cannot be discounted. In addition, many of the ideals of the masters of the High Renaissance, especially Raphael and Michelangelo, continued to affect the new generation of artists.

For example, Antonio Allegri, known as Correggio for his hometown, took the ideas of Michelangelo, Leonardo, and Raphael and added his own unique mindset to create ceiling frescoes and paintings that embody frank sensuality, whether inspired by religion or by mythology. The illusionism of his dome frescoes would have a strong influence on Baroque ceiling painters in the next century.

Working at the same time as Correggio, Francesco Mazzola, known as Parmigianino, might have been his student for a time. Although Parmigianino used anti-classical devices, he was also impressed with the grace of Raphael's painting. His *Madonna With the Long Neck* might well be

Detail from
The Last Supper
detail; JACOPO TINTORETTO (1518–94); 1592–94; oil on canvas. St. Giorgio Maggiore, Venice.
In a frenzy of religious zeal, the radiance of the light is transformed into a regent of angels that swoop in to bear witness to the momentous events of the Last Supper.

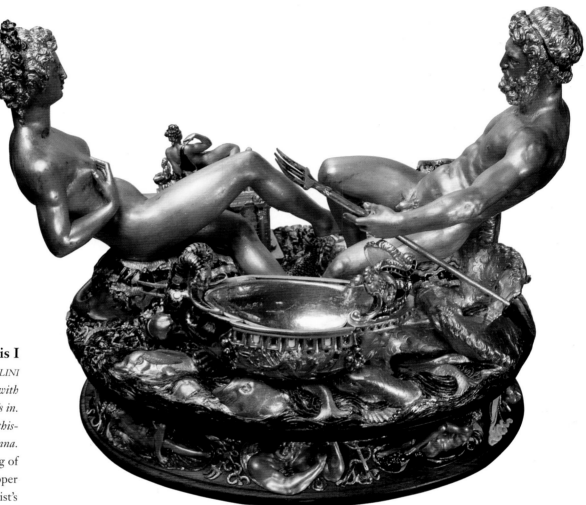

Saltcellar of Francis I
*BENVENUTO CELLINI
(1500–71); 1539–43; gold with
enamel; 10¼ x 13⅛ in.
(26 x 33.3 cm). Kunsthis-
toriches Museum, Vienna.*
Created for the King of
France, this salt and pepper
container displays the artist's
skillful technique in the
graceful elongated figures
that echo Mannerist paint-
ings. The man represents
Neptune, who guards the
salt that comes from his sea,
while the woman is Earth
watching over pepper, a
product of her ground.

the embodiment of Mannerist art, with figures that are curiously and consciously distorted beyond any sense of realism yet convey an air of cool elegance.

During the first half of the century, Mannerism was mostly confined to the artistic centers of Rome and Florence, but with the sack of Rome by the Imperial troops of the Holy Roman Emperor Charles V in 1527, artists spread out to other Italian cities and across Europe. Working half a century after Parmigianino in Venice, Jacopo Robusti, nicknamed Tintoretto ("Little Dyer") in reference to his father's trade, strove to achieve the colors of Titian combined with the poses of Michelangelo. Weaving aspects of mysticism with those of realism, Tintoretto created densely packed scenes with sharp angles that heighten bizarre perspectives. An unceasing play of color and light adds dynamism and directs the eye to important figures.

The last great Mannerist artist of the sixteenth century brought varied cultural influences to his paintings. Born in Crete, which was then ruled by Venice, Doménikos Theotokópoulos trav-eled to Venice, Rome, and finally Spain, where he was called El Greco. Working in the Spanish hotbed of the Counter-Reformation, El Greco also combined the mystical with the real to produce an emotional, religious art. His works are characterized by the dazzling colors of

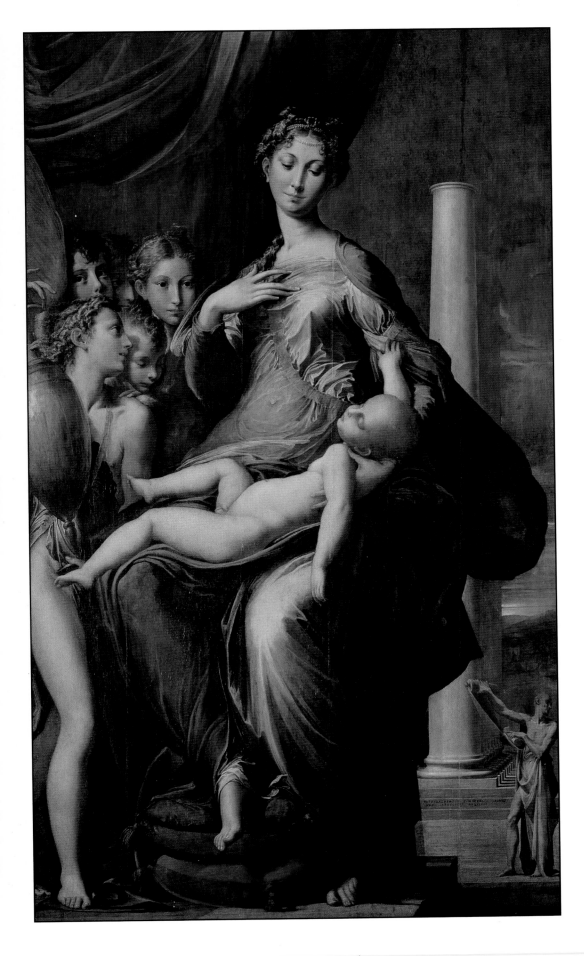

The Madonna With the Long Neck

PARMIGIANINO (1503–40); c. 1535; oil on panel; 7 ft. 1 in. x 4 ft. 4 in. (2.2 x 1.3 m). Galleria degli Uffizi, Florence. Inspired by Raphael, Parmigianino's Madonna is graceful though strangely distorted through elongation, as is the limp Christ Child and the long leg of the angel in the foreground. The meaning of the small out-of-scale man at the bottom right and the column—a single column on top but a row on the bottom—is unclear.

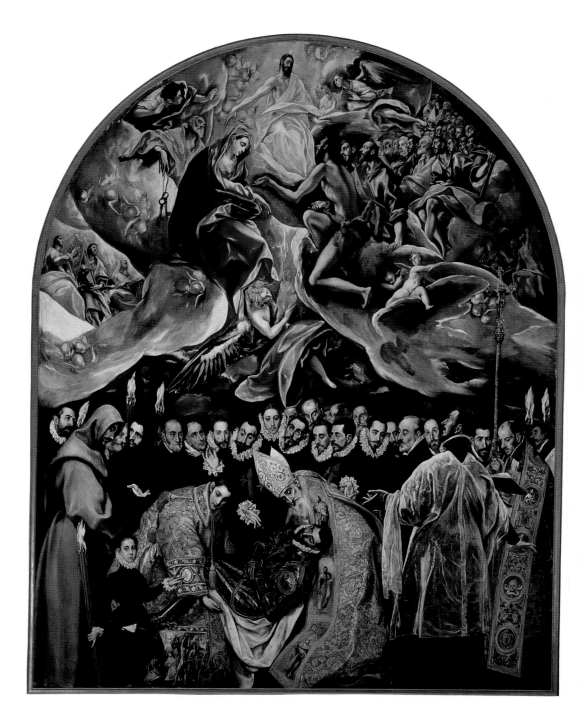

**The Burial
of Count Orgaz**
*EL GRECO (1541–1614);
1586; oil on canvas;
16 ft. x 11 ft. 10 in.
(4.9 x 3.6 m).
S. Tomé, Toledo, Spain.*
Like Tintoretto, El Greco
combined the actual and
the spiritual in his depiction
of the burial of the church's
benefactor in 1323. On
the bottom, a solemn
group watches the burial
while the eye is drawn
to the swirling angels
bearing the soul toward the
figure of Christ at the top.

Titian, the trademark elongated figures of Mannerism, a violent foreshortening, and sweeping movements.

Although Mannerism was primarily a phenomenon in painting, it did reach out to influence some sculptors, most notably Benvenuto Cellini, a Florentine goldsmith and sculptor who helped establish Mannerism in France during his employ by King Francis I, and Giovanni da Bologna, the Italianized name of the French artist Jean de Boulogne, who settled in Florence and became that city's most important sculptor in the sixteenth century.

In sculpture, as in painting, the technical achievements of the sculptor often took precedence over the actual content of the works. Bologna, for instance, created his masterpiece *The Rape of the Sabine Women*, which still stands near the Palazzo Vecchio in Florence, to conquer the technical problem of composing a work that could be viewed equally from all sides rather than having one dominant vantage point. The actual subject was of such little importance to him that he did not even name the sculpture; the title comes from contemporaries who debated the subject after the work was completed.

The Rape of the Sabine Women
*GIOVANNI DA BOLOGNA
(1529–1608); 1583; marble;
13 ft. 6 in. high (4.1 m).
Loggia del Lanzi, Florence.*
Bologna, also called
Giambologna, resolved
the problem of creating a
continuous vantage point by
placing the three corkscrew
figures in a single action
that must be viewed from
all sides. Such a work had
never before been constructed
in marble on such a large scale.

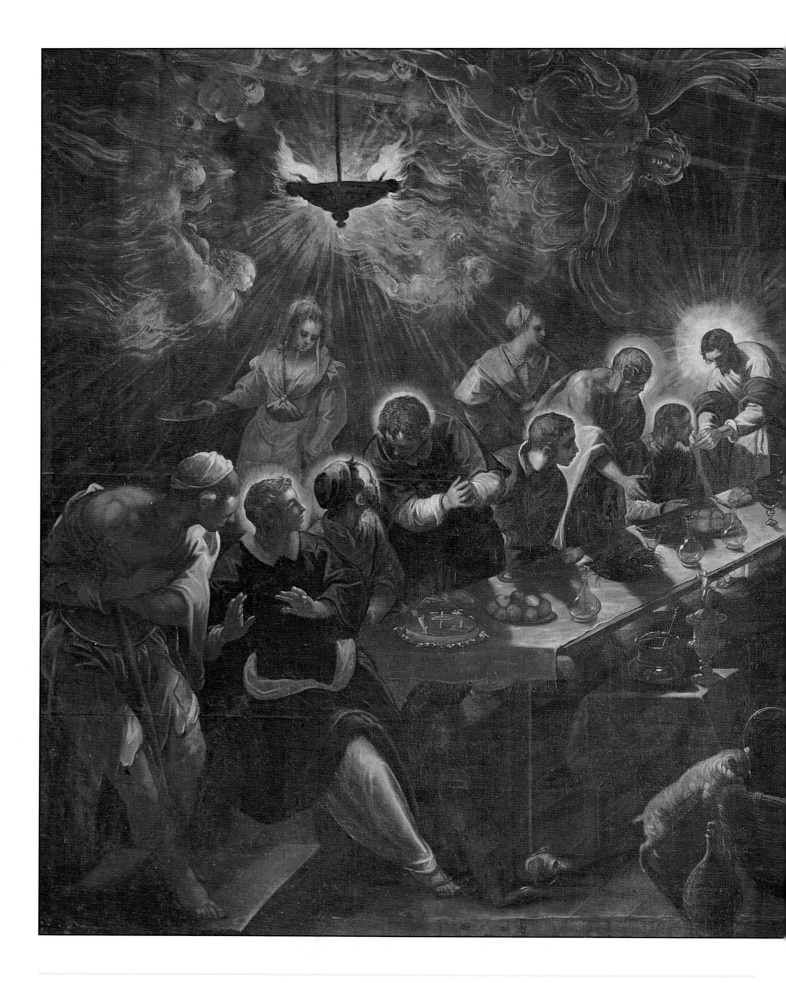

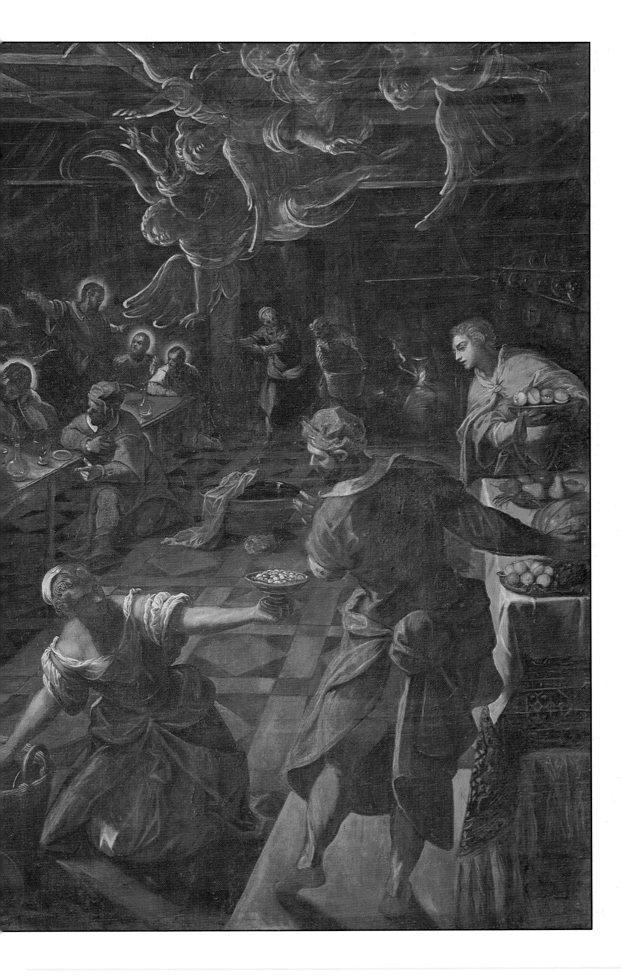

The Last Supper
JACOPO TINTORETTO
(1518–94); 1592–94;
oil on canvas;
12 ft. x 18 ft. 8 in.
(3.7 x 5.7 m).
St. Giorgio
Maggiore, Venice.
In a striking contrast
to Leonardo's *Last
Supper,* Tintoretto
commingled the su-
pernatural world of
flurrying angels with
the very real world
of animals and ser-
vants in his last major
work. Christ is buried
within the painting's
severe diagonal per-
spective, distinguish-
able only by the halo
that surrounds Him.

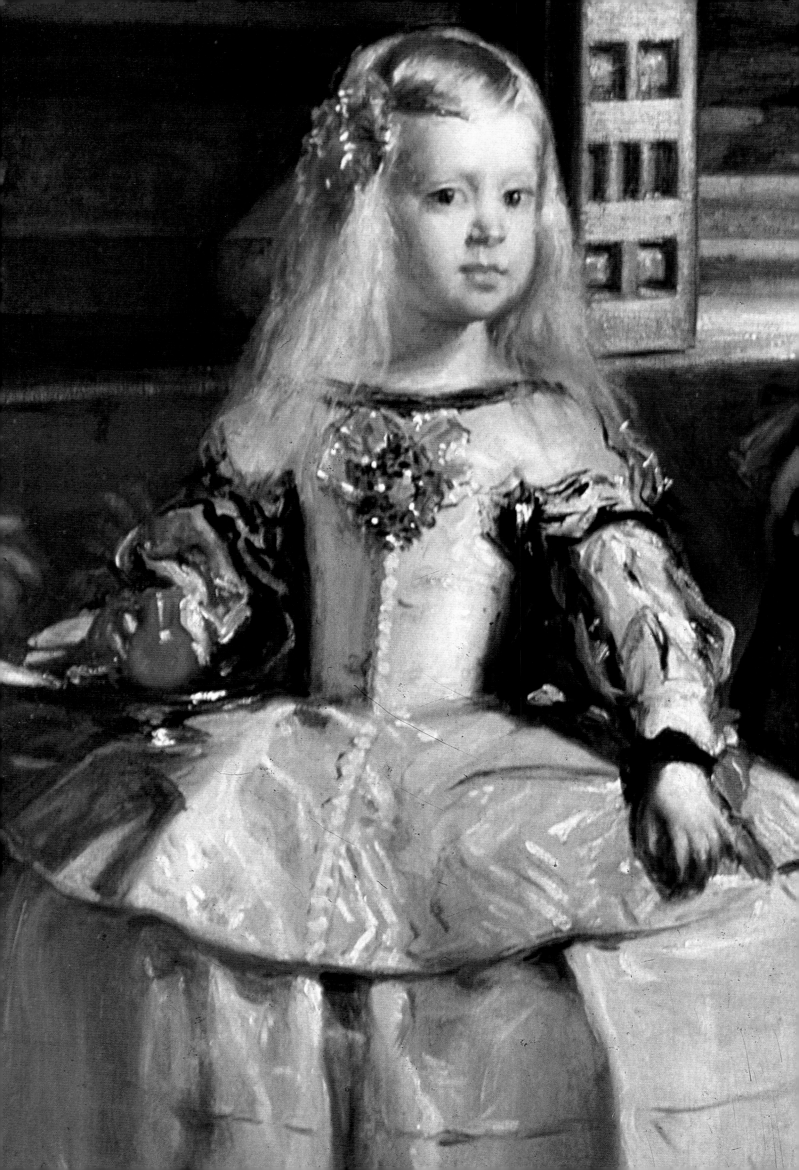

Baroque

From the late sixteenth century through the middle of the seventeenth century, almost all the important centers in Europe were undergoing radical political, religious, and philosophical changes. Protestant Holland broke ties with Catholic Flanders, which remained under Spanish control. Catholics throughout Europe rallied against the advent of Protestantism and the Counter-Reformation was begun. The Thirty Years War, from 1618 to 1648, started with the German Protestants against the Roman Catholics of numerous countries and became the first war to involve almost all of Europe.

In Italy, the Roman Catholic Church launched a campaign to transform Rome into the most magnificent of Catholic cities. In a building spree reminiscent of the Renaissance, numerous works of art and architecture were commissioned. Leaving behind the artful constructions of Mannerism, artists returned to some of the ideals of the Renaissance, but this time with the aim of achieving a dynamic motion that reflected the spirit of the times rather than the static serenity that characterized many Renaissance works.

The Baroque movement was not named until the late eighteenth century, by which time it had fallen into disfavor. The derogatory label was derived from the Portuguese word *barrocco*, which describes the irregular shape of pearls, and it was used to convey the ideas "absurd" and "willful." Characterized by diagonal movements and dramatic lighting, the goal of most Baroque art was to stir the emotions of a viewer, although there were numerous exceptions to this aim.

Two different trends evolved, the first spearheaded by Michelangelo Merisi, named Caravaggio after his hometown. He combined many of the elements of the preceding centuries, but in a way that led to a whole new kind of art. His figures were naturalistic but not idealized; his scenes mysterious but not really mystical; his themes religious but devoid of the symbolism associated with Mannerism.

Girl, from *Las Meninas*

detail; DIEGO VELÁZQUEZ (1599–1660); 1656; oil on canvas. Museo del Prado, Madrid.
At first glance, the beautiful Infanta Margarita appears to be the main subject of this painting. Captured in exquisite detail, she stands in the center, at the very edge of the brightly lit area in the front of the painting. Like the others, however, her role is to amuse the king and queen while Velázquez paints their portrait.

The Conversion of St. Paul

CARAVAGGIO (1571–1610);
c. 1601; oil on canvas;
7 ft. 6½ in. x 5 ft. 8⅞ in.
(2.3 x 1.75 m).
S. Maria del Popolo, Rome.
Caravaggio used dramatic light to theatrically capture the instant of Saul's conversion to the Christian Paul. In the life-size and lifelike figures, the artist has replaced the symbolism of earlier religious paintings with a new naturalism, seen in details such as the wrinkled forehead of the attendant and the beginning of a beard on Paul's face.

Caravaggio's paintings made use of violent gestures and physical movement to produce an emotional element. That intense sense of emotion was heightened by a dramatic *chiaroscuro* that placed the important events in bright light while leaving the background a murky dark field. Just as painters of the Northern Renaissance had moved religious scenes into contemporary settings, Caravaggio went a step further and stripped them of idealism so that in his *Call of Saint Matthew*, for example, both Christ and Matthew are barefoot and dressed like common people in a tavern.

Working at the same time, Annibale Carracci also moved away from Mannerism toward more naturalistic portrayals, but unlike Caravaggio, Carracci's naturalism was purged of all ugliness. Although he was not a theorist, Carracci synthesized techniques of Michelangelo, Raphael, and Titian with his own observations of nature, resulting in what would come to be the basis of academic theories for the next two centuries. Carracci is best known for the ceiling of the Farnese Palace, an illusionistic masterpiece of the loves of the gods painted as framed scenes within a painted simulation of sculpture and architecture.

Architecture and sculpture, too, were affected by this new move toward the blending of disparate elements to create a single unique, dynamic whole. In France, the formal gardens in front of Versailles, for example, are a logical extension of the façade of the sumptuous palace. In Rome, Gianlorenzo Bernini combined architecture, sculpture, and painting in St. Peter's to create what was called *un bel composto*—"a beautiful whole."

Another Italian painter, Artemisia Gentileschi, while not as influential with regard to actual painting techniques, is notable for being one of the first well known female painters. Working mostly in Naples, Gentileschi fused elements from Caravaggio with her own dramatic and violent vision. In many of her intense scenes, Gentileschi used dramatic *chiaroscuro* to highlight women playing a dominant role, as in the series of paintings from the Old Testament that depict Judith decapitating Holofernes. Other women who garnered acclaim as painters in the same period include the Dutch Rachel Ruysch, who painted still-lifes; Judith Leyster, who portrayed realistic slices of life in Holland; and, a bit later, Marie-Louise-Elisabeth Vigée-Lebrun, whose Rococo portraits were well known in France.

Rape of the Daughters of Leucippus

PETER PAUL RUBENS (1577–1640); c. 1616–17; oil on canvas; 7 ft. 3½ in. x 6 ft. 10¼ in. (2.22 x 2.09 m). Alte Pinakothek, Munich. Although known for his sensual use of color, Rubens also had a firm command of composition, as can be seen here. The two voluptuous women mirror each other's positions and the whole scene forms a diamond of intersecting diagonals that increases the sense of movement.

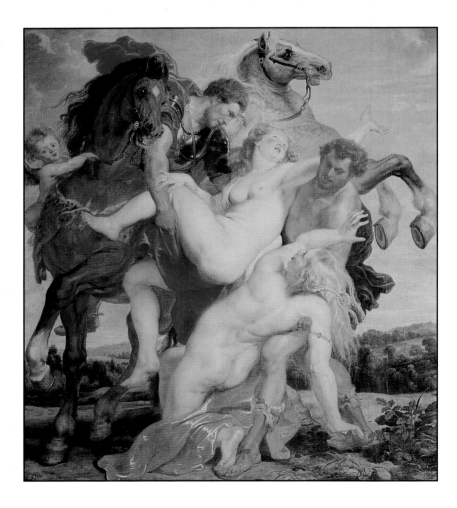

Judith and Maidservant With the Head of Holofernes

ARTEMISIA GENTILESCHI (c. 1597–1651); c. 1625; oil on canvas; 72½ x 55¾ in. (184.1 x 141.6 cm). The Detroit Institute of Arts. A single candle provides eerie lighting and shadows as Judith and her maidservant pause in the moment after the Jewish heroine has decapitated Holofernes, the enemy of her people. Gentileschi often painted dramatic, sometimes violent scenes of strong women in action.

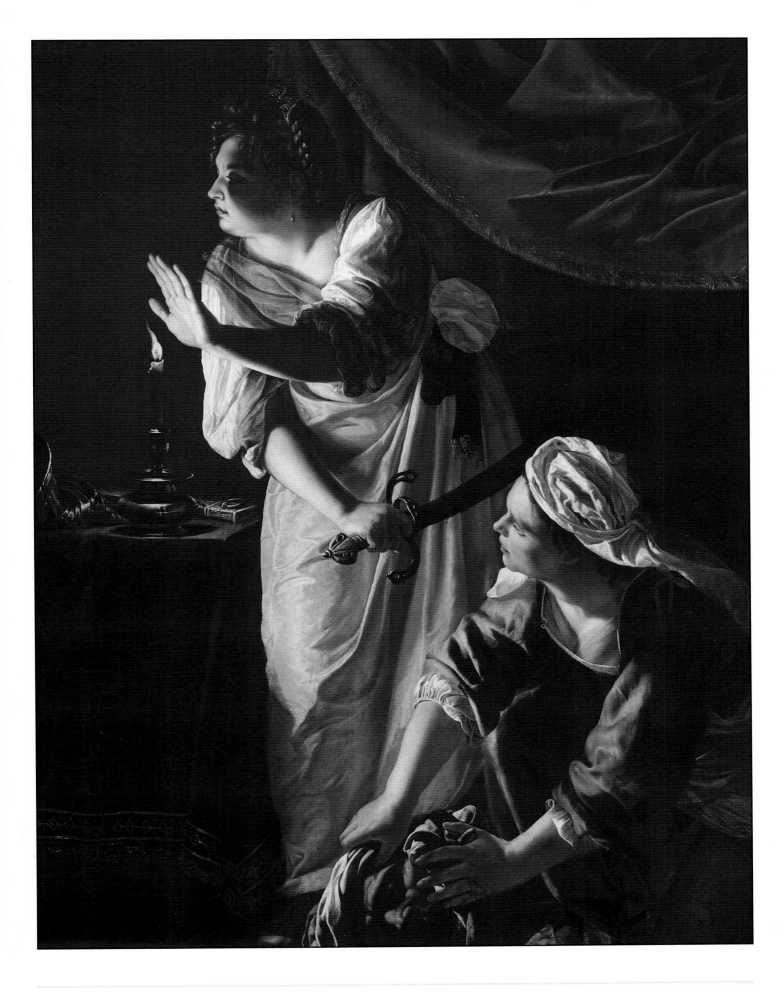

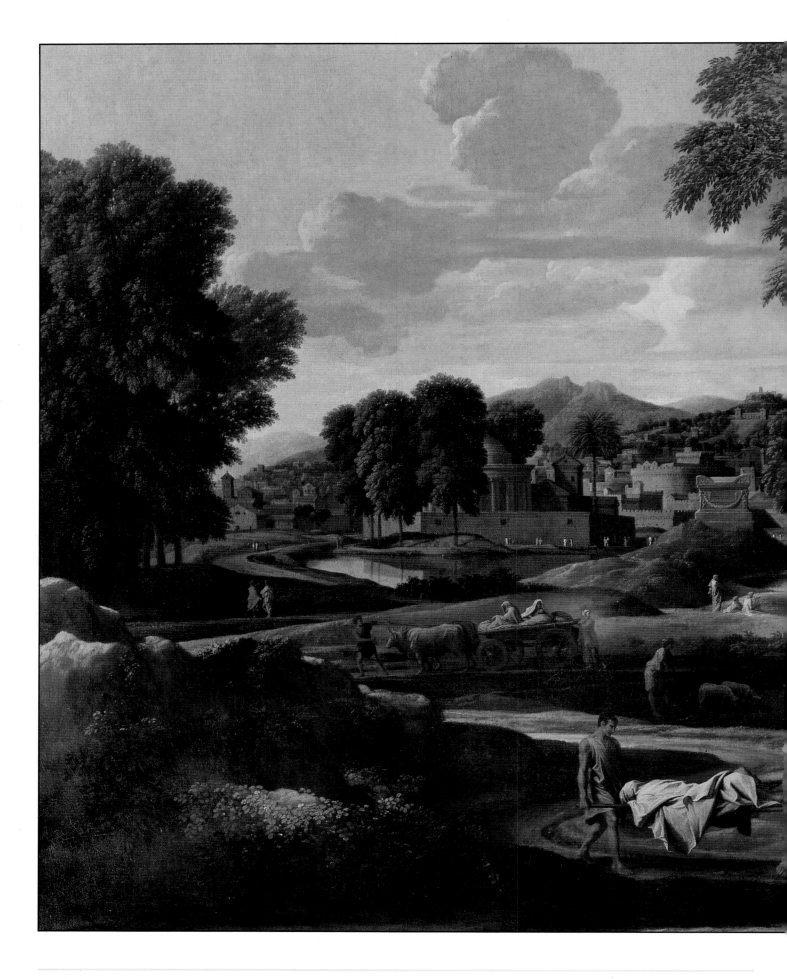

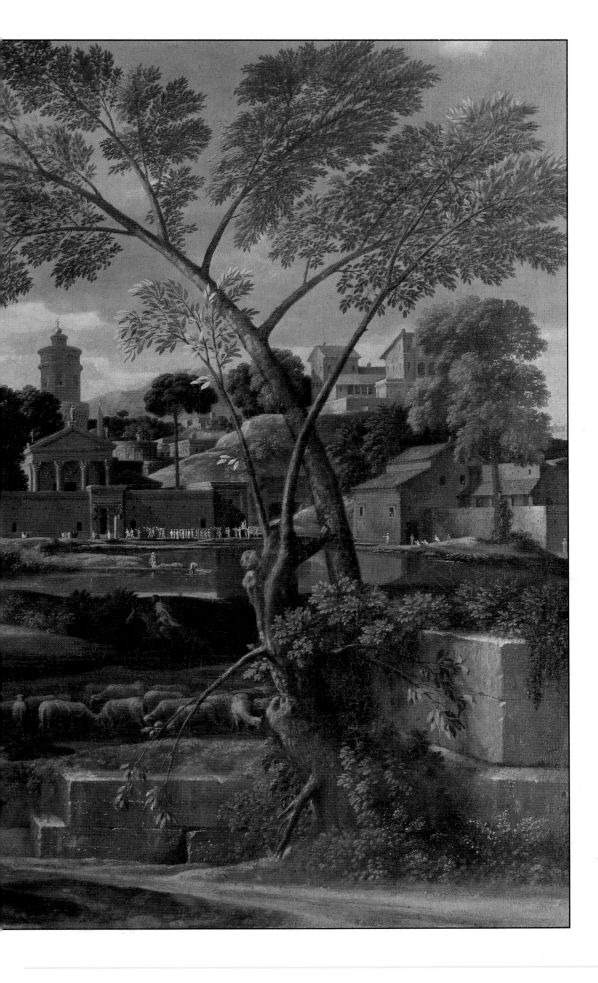

Landscape with the Burial of Phocion

*NICOLAS POUSSIN
(1594–1665); 1648;
oil on canvas; 47 x 70½ in.
(119.7 x 179 cm).
Musée du Louvre, Paris.*
Poussin often portrayed
scenes from mythology
in idealistic landscapes
wherein each element
is carefully constructed
to enhance the sense of
balance. The dark colors
on the bottom and the
deep landscape here
provide a somber back-
ground appropriate to
the solemn nature of
the death of the hero.

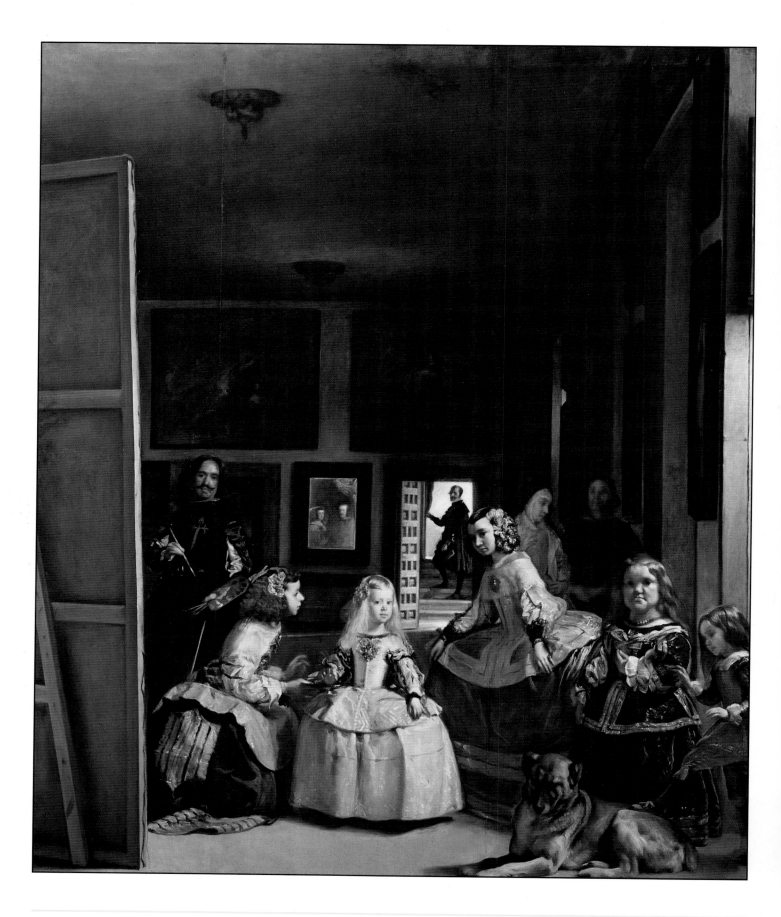

Las Meninas (The Maids of Honor)

DIEGO VELÁZQUEZ (1599–1660); 1656; oil on canvas;
10 ft. 5 in. x 9 ft. (3.2 x 2.7 m). Museo del Prado, Madrid.
In a complete break with tradition, Velázquez portrayed
a seemingly insignificant incident in daily court life.
The attention of all the figures is on the place where
the viewer stands, watching and entertaining the
king and queen, who are seen only in the mirror in
the background while the artist paints their portrait.

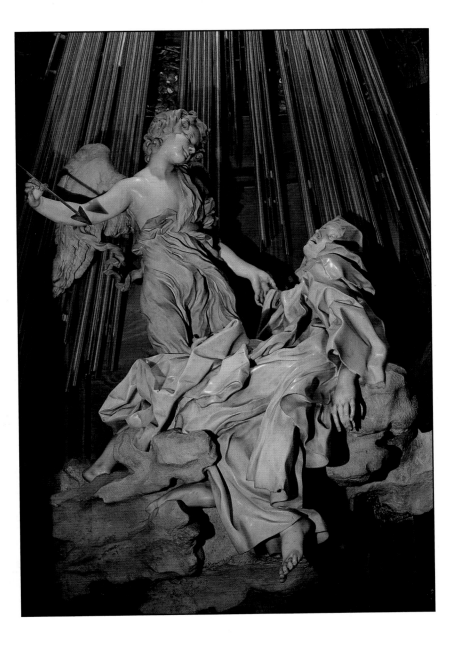

In the meantime, the Baroque style was
moving out of its center in Italy to affect artists
throughout Europe. While it maintained its
basic character—bold foreshortening, powerful
realism, dramatic, even theatrical use of light
and shade, and an increase in the expression of
emotion—the movement's true strength may
have been its ability to be adapted to regional
characteristics and the personal stamp of
individual artists.

In Spain, for example, Diego Velázquez was
influenced by Caravaggio but also by the
brilliant color and fluid brushstrokes of Titian,
which, as court painter to Philip IV, he was able
to study in the Royal Collection. Just as Car-
avaggio had stripped religious figures of idealism
to portray them realistically for the first time,
Velázquez was similarly innovative in portraying
the royal family and its attendants in a slice-of-
life portrait, *Las Meninas (The Maids of Honor)*.

In France, however, Nicolas Poussin, influ-
enced by neither Caravaggio nor Carracci, came to be the dominant force. Believing that
the highest goal of painting was the depiction of noble and serious human action, Poussin
advocated a rational and intellectual approach to painting, in the style of the Renaissance
masters. The calm and stable style he adopted, with its academic and systematic focus,
was well suited to his choice of what he considered to be "important" subjects, such as
battles and heroic action, history, and religious themes.

The differences between Poussin and another great Baroque painter, Peter Paul
Rubens, were so great that artists would debate the merits of one against the other until
the mid-eighteenth century. Although the names are no longer used, there are still those
who argue these same questions—essentially, is it more important for art to appeal to the
intellect or to the senses. Those who called themselves Poussinistes advocated Poussin's
concept that drawing, which appealed to the intellect, was more important than color,
which made an impression on the eye and the senses. Those in Rubens's camp, the
Rubenistes, stressed that emotive color was necessary for a truthful representation of
nature, their goal in art.

The Ecstasy of St. Theresa

GIANLORENZO BERNINI (1598–1680);
1645–52; marble; 11 ft. 6 in. high
(3.5 m). Cornaro Chapel,
Sta. Maria della Vittoria, Rome.
Bernini incorporated his sculpture
with the architecture around it,
even to controlling the light
which comes from a hidden source
above, creating a dramatic and
intense focal point. Above is a
ceiling fresco of the heavens to
which the saint will ascend while
sculptured figures watch from
balconies as though at the theater.

Rubens, a diplomat as well as an artist, had studied in Italy and his paintings incorporate the musculature of Michelangelo, the dramatic lighting of Caravaggio, and the brilliant colors of Titian. This Flemish master, perhaps most famous for his personal concept of the fleshy, full-figured female ideal, glorified sensual pleasure, employing splendid color and vigorous brushwork to delight the senses. His huge canvases are packed with elaborate activity in dynamic motion. His student Anthony van Dyck became famous for his portraiture.

While art in Catholic Flanders continued to incorporate religious and mythological scenes, art in newly independent Protestant Holland veered toward secular subjects, such as portraits, still-lifes, and landscapes. Rembrandt van Rijn, known today simply as Rembrandt, specialized in the newly popular group portraits demanded by middle-class Dutch citizens. Instead of the grand scale of other Baroque works, many of his are intimate and revealing explorations of his subjects. His paintings are especially known for the richness of their brushwork and warm, golden tones, with a sensuous accommodation of lights and darks. A leading painter of his time, Rembrandt's long career included a passion for printmaking as well as more than one hundred self-portraits.

Jan Vermeer, also in Holland, continued a tradition that had begun when northern European painters brought religious figures indoors to middle-class households. Now, though, Vermeer eliminated the religious aspects, focusing solely on quiet domestic scenes, carefully designed with a sensitive use of light and colors that tended to blues and yellows.

The Night Watch

REMBRANDT (1606–69);
1642; oil on canvas;
12 ft. 2 in. x 14 ft. 7 in.
(3.8 x 4.4 m).
Rijksmuseum, Amsterdam.
A master of the group and individual portrait, Rembrandt filled this massive painting with bustling activity: the men fiddle with their guns, a dog barks, the drummer plays. An eerie glows calls attention to some figures while others are partially obscured by other people or by shadows.

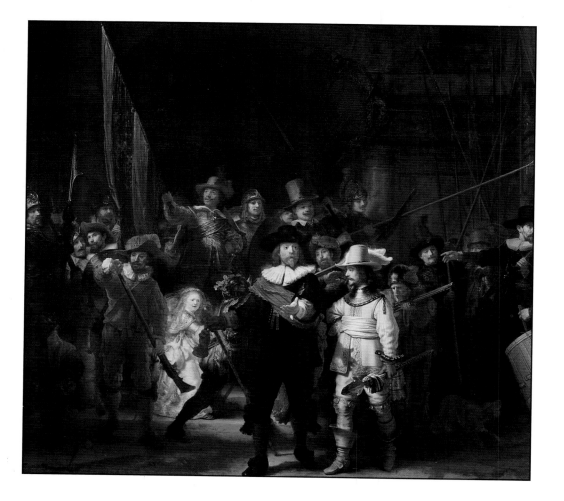

The Love Letter

JAN VERMEER (1632–75);
c. 1666; oil on canvas;
17¼ x 15¼ (43.3 x 38.3 cm).
Rijksmuseum, Amsterdam.
Although a quiet domestic scene, this painting makes use of the luminous light and shadows typical of Baroque painting. The two women are framed within the doorway as though the viewer is watching them through a window, while the diamonds on the floor lead to the women.

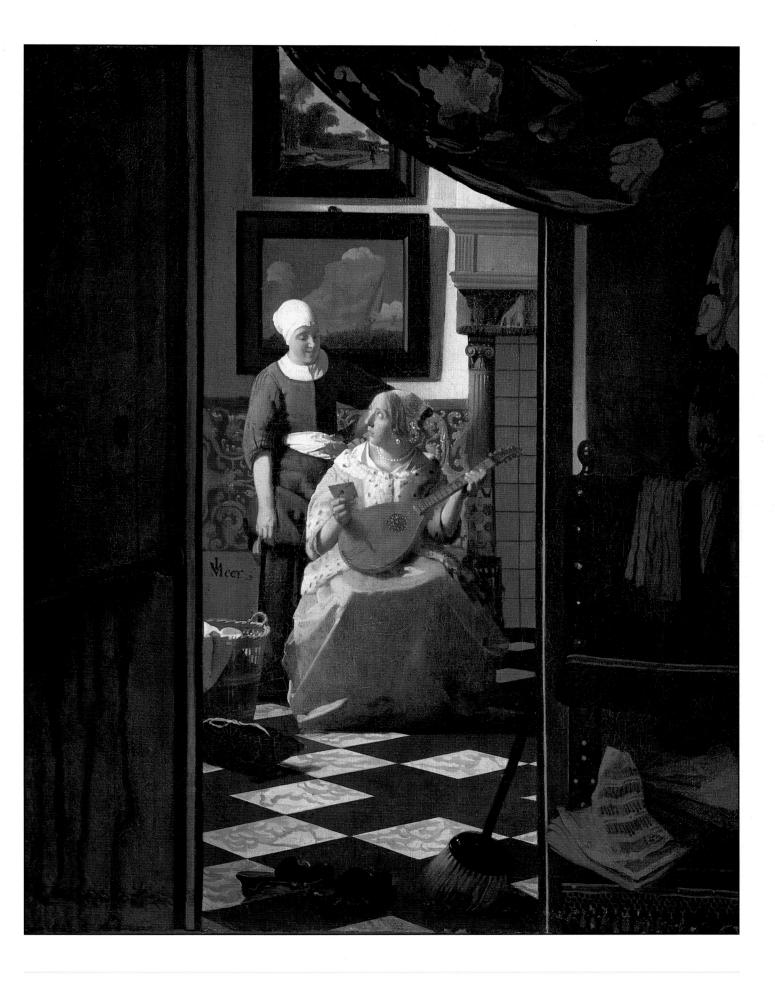

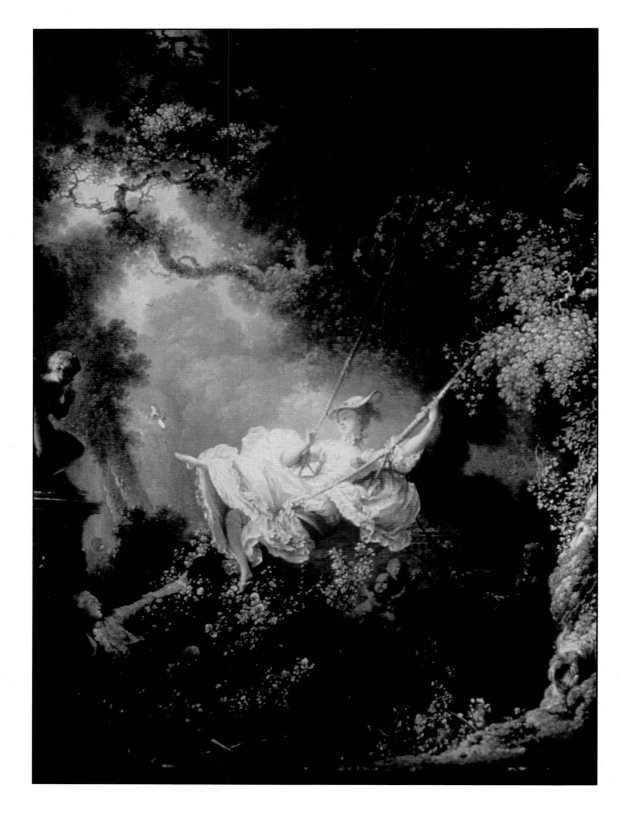

The Swing

JEAN-HONORÉ FRAGONARD (1732–1806); 1767; oil on canvas;
31 7.8 x 25 1.4 in. (81 x 64.2 cm). Wallace Collection, London.

A scene of sensuous intrigue is hidden in the misty blue-green foliage surrounding the young
lady in the frothy pink dress. Partially hidden near her feet, a young man reaches his hat out
as her slipper seems to fly off—both understood to be erotic images in the eighteenth century.

Rococo

In Paris, the Poussinistes were dominant until the end of the seventeenth century, in large part because of the Royal Academy of Painting and Sculpture, created in 1648. There, young artists learned the rules and theories of art, with an emphasis on the noble art of the ancients. But when Louis XIV died in 1715, a new feeling pervaded France. The center of court life moved from Versailles back to Paris, where new townhouses needed decorations. The name Rococo actually began as a description of the elegant high-fashion decoration of the upper classes and was later extended to include painting, sculpture, and architecture.

The Rubeniste admiration for color and appeal to the senses triumphed in the form of brighter colors, more free-flowing brushwork, and images of pleasure. Freed from strict academic rules, artists emulated these new lighter fashions in their works, creating joyful paintings that often focused on love of all kinds—romantic love, erotic love, even mother love. The goal of Rococo art was not to inform or to objectively depict nature but to entertain, to evoke a sensual, visceral delight in the viewer.

Although the subject matter of Rococo art was usually considered trivial by the more academic Poussinistes, the style achieved some respect in the talented hands of Jean-Antoine Watteau, the first Rococo artist admitted to the Royal Academy. The Academy even devised a new term for his paintings, which featured well-dressed men and women enjoying themselves outdoors in a festive somewhat fantasylike world—*fêtes galantes.* Jean-Honoré Fragonard, another French Rococo painter, painted similar scenes, with even more sensuous interplay between men and women.

A Pilgrimage to Cythera

Jean-Antoine Watteau (1684–1721); 1717; oil on canvas; 4 ft. 3 in. x 6 ft. 4½ in. (1.3 x 1.9 m). Musée du Louvre, Paris.
Watteau seamlessly merged fantasy and reality in his joyous paintings. The well-heeled couples accurately reflect the look of eighteenth-century France, but the flying cherubs spring from mythology, as does the island of Cythera, a mythical island of love.

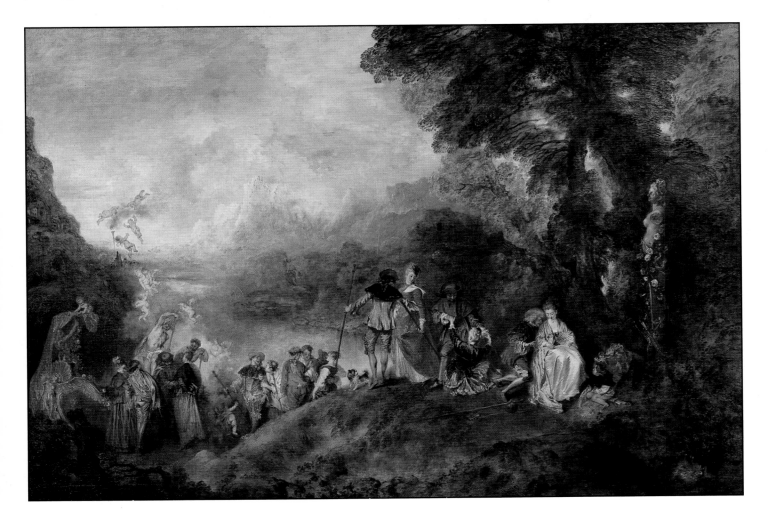

Although Rococo was primarily a French phenomenon, it did achieve some measure of influence upon English painters, especially Sir Joshua Reynolds. Reynolds founded and was the first president of the Royal Academy in England and claimed to support the academic and formal ideals of Poussin. His own paintings, however, reflected the decorative elements of Rococo, the lighting of Baroque, and a less weighty subject matter than his avowed preference for grand historical subjects. Since he painted primarily portraits, he achieved his desire to paint more noble subjects by imbuing his sitters with historical and mythological allusions, as in *Mrs. Siddons as the Tragic Muse.*

In Germany, the taste for Rococo prevailed in sumptuous palaces, where painting, architecture, and sculpture were unified with ornate, sometimes overwhelming detail and shimmering decoration. At the same time, the Germans rediscovered the ancient Chinese art of manufacturing porcelain. Meissen ware, the first ceramic ware to incorporate these newly discovered techniques, became tremendously popular, and it was not long before every court in Europe had its own porcelain manufacturer.

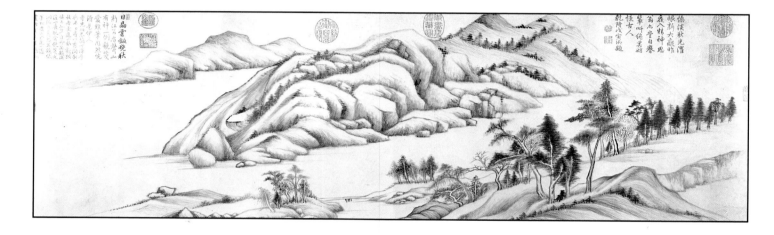

Autumn Mountains

DONG QICHANG (1555–1636); early 17th century; hand scroll, ink on paper; 15¹⁄₈ x 53⁵⁄₈ in. (38.4 x 135 cm). Cleveland Museum of Art, Cleveland. Considered the preeminent painter of the Chinese Ming Dynasty, Qichang applied the principles of calligraphy to his highly abstracted landscapes. His emphasis on the spiritual qualities of painting rather than a representation of nature had a long-lasting influence on Chinese, Japanese, and, eventually, European painting.

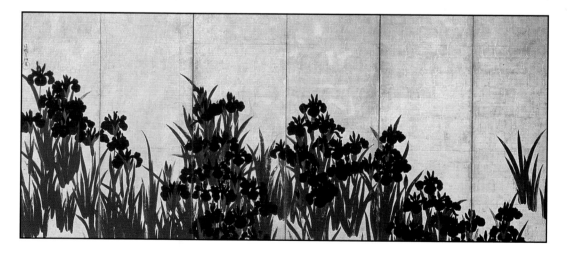

Irises

OGATA KORIN (1658–1716); pair of six-fold screens, color and gold leaf on paper; 4 ft. 11 in. high (1.5 m). Nezu Institute of Fine Arts, Tokyo.
During the relative calm of the Edo Period, Korin and others painted decorative secular screens that continued the tradition of "floating world" paintings. Using bold forms and vibrant color, Korin created elegantly simple scenes from nature set against gold leaf that had a profound influence on nineteenth-century European painters.

**Mrs. Siddons as
the Tragic Muse**
*SIR JOSHUA REYNOLDS
(1723–92); 1784;
oil on canvas; 93 x 57½ in.
(236.5 x 146 cm).
Huntington Art Gallery,
San Marino, California.*
In an effort to impart a
greater sense of historical
importance to his por-
traits, Reynolds often
posed his fashionable
sitters in classical posi-
tions with references to
mythology. The Baroque
lighting enhances the
sense of otherworldliness.

THE MODERN AGE

In the mid-eighteenth century, the lightness and frivolity of Rococo art began to give way to an interest and revival in the principles of classical art. The arts of antiquity had been inspiring artists since the Renaissance, but now they gained new importance as archaeologists rediscovered the treasures of Pompeii and Herculaneum. Such discoveries provided new information about classical design and ornamentation and allowed artists to look at classical art anew, without the filter of Renaissance principles.

At the same time, the political revolutions in France and the United States, along with a new interest in scientific and rational approaches to social and economic endeavors, led artists to return again to a past perceived as noble and enlightening.

Neoclassicism Through Realism

Italy experienced an increase in sculpture that emulated the serene nobility of the Greeks; the archaeological research of Johann Joachim Winckelmann had prompted him to differentiate between Greek classical art, which he praised, and Roman classical art, which he denounced. In the United States, Thomas Jefferson applied the revived ideals to architecture, creating masterpieces such as his home, Monticello. Neoclassicism gathered even more strength in France, where painters would soon take the lead in developing new theories in the arts.

The emphasis changed from a loose definition of form through brushwork to a more formal linear definition. In keeping with the turbulent times, artists showed an interest in more serious subject matter, following the precept that art should be both pleasing to the eye and informative, as opposed to what was considered the self-indulgence and aristocratic

Odalisque
EUGÈNE DELACROIX (1798–1863); 1845–50; oil on canvas; 14⅞ x 18¼ in. (37.3 x 46.5 cm). Fitzwilliam Museum, Cambridge.
Inspired by Rubens, Delacroix believed color and brushwork were the fundamentals of painting. His *Odalisque*, as richly colored as that of Ingres's, reclines in relaxed and unashamed abandon, a far cry from the cool reserve and sharp angles of Ingres's work.

Boy, from *Studio of a Painter*
detail; GUSTAVE COURBET (1819–77); 1854–55; oil on canvas. Musée d'Orsay, Paris.
Velázquez and Goya had brought the artist into the periphery of compositions, but Courbet went a step further and placed himself as the central figure, perhaps a response to his unkind treatment by the established art juries. The little boy who watches has been likened to the innocent eye of the artist; he might as easily symbolize the unfettered admiration an artist craves.

The Family of Charles IV

Francisco de Goya (1746–1828); 1800; oil on canvas; 9 ft. 2 in. x 11 ft. (2.8 x 3.4 m). Museo del Prado, Madrid. As in Velázquez's *Las Meninas*, Goya here uses the device of portraying himself painting the royal family. Despite the luminescent quality of light and the splendid royal costumes, the portrait is hardly flattering to any of the royal family.

sensibilities of Rococo art. Jacques-Louis David, who started his career as a painter for King Louis XVI and eventually worked for Napoleon, was the major proponent of Neoclassicism in France, imbuing most of his works with the Republican ideals he espoused.

His student, Jean-Auguste-Dominique Ingres, too young to be greatly concerned with Napoleon and the Republican ideals that had so inspired David, continued his teacher's ideas regarding linear contour and simplicity of figures as the most important elements of art. The battle that had raged in the late seventeenth century between the Poussinistes and Rubenistes was revived, with Ingres as a major proponent of the Poussiniste concept of academic and intellectual drawing, and his contemporary Eugène Delacroix emerging as a champion of the Rubeniste view that color was the most important aspect of painting.

Along with this renewed interest in color, artists rebelled against the rigid academism of the Neoclassical ideals, focusing less on universal truths and more on their own individual hopes, fears, and beliefs. Romantic ideals—with an emphasis on subjective interpretations and the concept of intuition over reason—opened the door to freedom in artistic technique.

Unlike Neoclassicism, which was an actual style of art, Romanticism emerged as more of a shared sensibility, with numerous expressions. In both art and literature, the supernatural

Odalisque

Jean-Auguste-Dominique Ingres (1780–1867); 1814; oil on canvas; 35¼ x 63¾ in. (89.7 x 162 cm). Musée du Louvre, Paris. Although Neoclassical in its smooth surfaces and obvious regard for the sculptural form, Ingres utilized the Near Eastern subject matter of the Turkish harem woman and expressive color, both Romantic trends. The woman, while clearly not idealized, is also far from realistic; the elongated form is almost Mannerist.

The Death of Marat

*JACQUES-LOUIS DAVID
(1748–1825); 1793; oil on
canvas; 5 ft. 3 in. x 4 ft. 1 in.
(1.6 x 1.25 m). Musée
des Beaux-Arts de
Belgique, Brussels.*
David found inspiration
in classical mythology as
well as current events.
This painting immortalizes
the journalist Jean-Paul
Marat, a friend of David,
who was killed in his
bathtub by a political
enemy, Charlotte Corday.
Details such as the letter,
pen, and knife stand out
in the spareness of the
horizontal composition.

became increasingly popular, in addition to a growing fascination with all things exotic, the potential for violence, and nature in all its moods. In France, Delacroix applied color and brushwork to create a dynamic emotive energy, while in Spain, Francisco de Goya incorporated many of the characteristics of Baroque art, using dramatic lighting, painterly brushwork, and diagonal forces within his compositions. In England, Joseph Mallord William Turner painted natural subjects such as mountains and the sea in atmospheric compositions of light and color that could be considered forerunners of Impressionism.

By the middle of the nineteenth century, however, the arts themselves underwent a change. The royal houses that had supported artists were disappearing and artists were facing a new reality of having to make a living. The advent of the Industrial Revolution and a newly discovered middle class demanded art that was not academic and idealized like Neoclassicism,

The Fifer
*EDOUARD MANET
(1832–83); 1866;
oil on canvas;
5 ft. 3 in. x 3 ft. 2¼ in.
(1.6 x .98 m).
Musée d'Orsay, Paris.*
Manet brought realism to
an extreme devoid of all
emotion. Although he
employed realistic fore-
shortening, there is little
depth in the painting and
the gray background seems
almost as near as the figure,
making the work appear two-
dimensional and flat rather
than three-dimensional.

nor escapist like Romanticism, but something which reflected the truer aspects of everyday life.

Gustave Courbet, an artistic leader in mid-nineteenth century France, portrayed ordinary people leading ordinary lives. Rejecting anything not directly related to real life, Courbet is quoted as saying: "Show me an angel and I will paint one." Based on Courbet's ideals, a group of artists in Paris began to devise new methods of pictorial representation, focusing on scientific concepts of vision and the study of the properties and optical effects of light, which would play a great role in the coming Impressionist movement.

Although young, rebellious artists were experimenting with these techniques and sensibilities, the all-important academies of Paris, Rome, and London were not ready to change. By 1863, there was such a rift between the academics and the new trends in art that the official judges of the state-sanctioned Salon in Paris refused the majority of the works that were submitted. In response, Napoleon III took the bold step of creating a new arena within which the rejected artists could exhibit their works, called the Salon des Refusés.

Edouard Manet was one of the artists to exhibit there, showing his painting *Luncheon on the Grass*, in which naked women picnicked with fully clothed men. The work was considered scandalous, not fitting into the category of either allegory or real life. Manet's later works are even more startling, not so much for their subject matter but because of the complete lack of emotion they betray. He chose realistic subjects, such as *The Fifer* or *The Execution of the Emperor Maximilian*, and rendered them in such a way that they became a flat statement of what the eye perceives. Believing that brushwork and color were the essential qualities of a painting, Manet was one of the first to advocate "art for art's sake."

The Slave Ship

JOSEPH MALLORD WILLIAM TURNER (1775–1851); 1840; oil on canvas; 35¾ x 48¼ in. (90.8 x 122.6 cm). Museum of Fine Arts, Boston.

The exuberant orange and red clouds in the background almost mask the true subject of this painting, a response to the horrific practice of slave trading. One has to look closely to see the ship buffeted by huge waves and the manacled hands and legs of the slaves who have been tossed overboard.

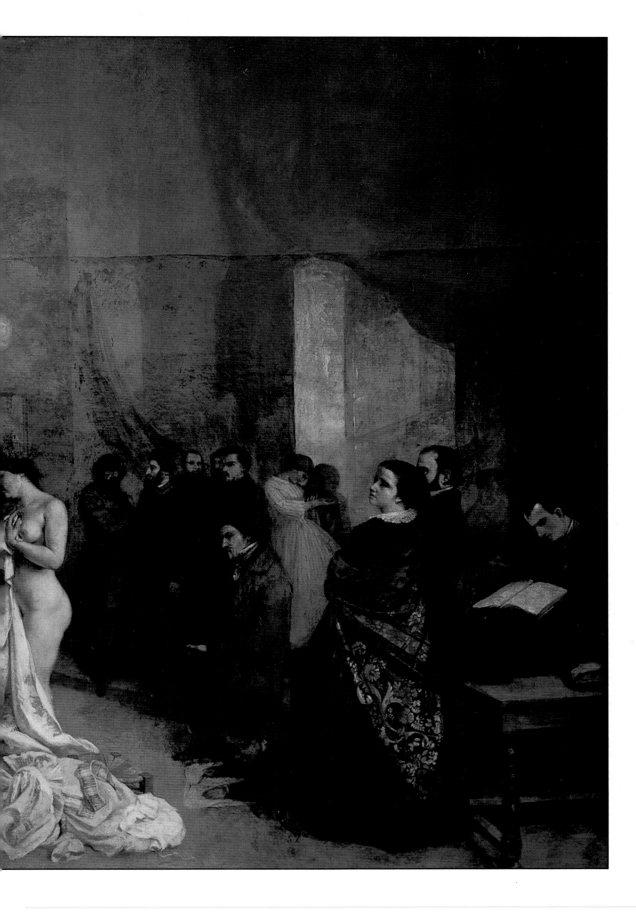

**Studio of
a Painter:
A Real Allegory
Summarizing
My Seven
Years of Life
as an Artist**
*GUSTAVE COURBET
(1819–77);
1854–55; oil on
canvas; 11 ft.
10 in. x 19 ft. 7 in.
(3.6 x 6 m). Musée
d'Orsay, Paris.*
Courbet believed in
painting real people
at their everyday
activities. Here, the
subject is his own
studio, showing off
the new role of the
artist in society.
On the left are
ordinary models,
on the right friends
(writers George
Sand and Charles
Baudelaire are
identifiable).
Courbet, the artist,
takes center stage
in sharp daylight.

The Thinker
AUGUSTE RODIN (1840–1917);
1880 (enlarged 1902–4); bronze;
6 ft. 7 in. x 4 ft. 3¼ x 4 ft. 7¼ in.
(2 x 1.3 x 1.4 m). Musée Rodin, Paris.
Although Rodin's sculptures mirrored
some of the trends of Impressionism,
most notably an attention to the way
the light played against surfaces,
many of them were also quite realistic.
The Thinker, for example, shows the
strong influence of Michelangelo in
its detailed and realistic musculature.

Arrangement in Black and Gray: The Artist's Mother

JAMES ABBOTT MCNEILL WHISTLER (1834–1903); 1871; oil on canvas; 4 ft. 9 in. x 5 ft. 4½ in. (1.45 x 1.64 m). Musée d'Orsay, Paris. Concerned more with the arrangement of shapes, colors, and composition than with the subject matter, Whistler was an advocate of "art for art's sake." He saw analogies between the qualities of art and music, frequently naming his paintings "nocturnes," "symphonies," or "arrangements."

The Tub

EDGAR DEGAS (1834–1917); 1886; pastel; 23½ x 32⅓ in. (59.7 x 82.3 cm). Musée d'Orsay, Paris. Degas used geometric forms and a flattened image to give the appearance of looking down upon the woman from a high angle. Although the angle makes the painting appear almost two-dimensional, the woman's body is strongly contoured and outlined.

Les Nympheas (The Water Lilies)

CLAUDE MONET (1840–1926); 1920–22; oil on canvas;
6 ft. 6¾ in. x 13 ft. 11¾ in. (2 x 4.25 m). The St. Louis Art Museum, St. Louis.
Monet remained true to the Impressionist spirit throughout his career and the water
lilies in his Japanese-style garden at Giverny became a favorite late subject. Painting the
scene again and again, the artist focused on capturing the colors of the lily pads and flowers
as they changed to reflect different times of the day and a variety of weather conditions.

Le Moulin de la Galette

AUGUSTE RENOIR (1841–1919); 1876; oil on canvas; 4 ft. 3½ x 5 ft. 9 in. (1.3 x 1.75 m). Musée d'Orsay, Paris.

Full of light, color, and movement, this painting offers the viewer a fast glimpse into a fun-filled afternoon in nineteenth-century Paris. In a nod to Japanese prints and photography, the figures at the edges are apparently arbitrarily cut off, accurately reflecting what a human eye would see while passing by.

days and at different times, interested more in portraying the effects of the shifts of light through experiments with color and method than in depicting the actual petals of the lilies.

Renoir, on the other hand, preferred the human form, captured in realistic situations and infused with brilliant color and light. His compositions, unlike earlier traditions, are not neatly framed within the borders of a painting; it is clear that the action extends beyond the edges even if the viewer can no longer see the activity. Degas, too, preferred human subjects, such as ballet dancers, couples, and nudes, working in a studio to experiment with the various permutations of light indoors rather than outdoors. He differed from the others in his choice of more muted colors, his allegiance to traditions such as outlining forms, and his spatially complex compositions, yet his paintings are distinctly Impressionist in their brushwork and luminous lighting.

While painting was undergoing such radical changes, sculpture, too, was in a state of flux, in large part because of the efforts of Auguste Rodin. Rodin, because his sculpture defies traditional labels, has been categorized as everything from a Realist to a Symbolist. Like the Impressionists, he was concerned with the effects of light and shadow in his works; like the Realists, his sculpture is evocative of inner feeling; like the Neoclassicists, he took inspiration from classical mythology. This synthesis of old and new, radical and often misunderstood at the time, paved the way for a new kind of modern sculpture.

The Coiffure
*MARY CASSATT
(1844–1926); 1891;
color print with dry-
point, soft-ground
and aquatint;
14 ³/₆ x 10¹/₂ in.
(36.5 x 26.7 cm).
Cleveland Museum
of Art, Cleveland.*
Independently
wealthy, Cassatt was
able to pursue her ca-
reer as an artist at time
when it was deemed
unsuitable for women;
she not only succeed-
ing but became the
most influential Amer-
ican artist of her time.
Like this portrayal of
a woman fixing her
hair, many of Cassatt's
paintings centered on
the daily experiences
of domestic life.

Post-Impressionism

Unlike Monet, who adhered to Impressionist principles throughout his career, most other artists who started out Impressionistic eventually changed their methods. The shimmering light and atmospheric effect that helped capture the surface illusion of fleeting views usually led to indistinct, hazy forms that came to be regarded by many of the period as lacking any deeper meaning. At the same time that artists were beginning to seek a more personal relevance in their works, society was confronting the changes wrought by the Industrial Revolution. These two trends together affected the artists who led Impressionism to its next stages and helped direct art into the twentieth century.

Many of the artists influenced by Impressionism continued to adhere to some of its principles—most notably the bright colors that characterized the school—while moving in a range of new directions, with the result that no singular style evolved immediately after Impressionism.

Georges Seurat, for example, stayed with the realistic subject matter and bright colors of the Impressionists but took the scientific study of color and the effects of light to a new extreme. Using the intuitive color patches of the Impressionists and the broken colors of the Romantic painters John Constable and Delacroix as a starting point, Seurat attempted to impose order on Impressionist techniques by presenting color within a more structured framework. To do so, he calculated the exact proportions of specific colors needed to achieve optical color mixtures when viewed at the proper distance. He also altered his very brushstrokes, first to small strokes side by side then finally to uniform colored dots, a technique termed pointillism or divisionism. Unlike the Impressionists, Seurat made many preliminary sketches outside before moving indoors to the studio, where he composed paintings with structure and formal design.

Cézanne also employed the colors of Impressionists as a starting point, but then devised another method of defining space called color modeling. Instead of using the linear perspective

The Bathers

GEORGES SEURAT (1859–91); 1883–84; oil on canvas; 6 ft. ½ in. x 9 ft. 10½ in. (2.02 x 3 m). The National Gallery, London. Although this painting has the shimmering light of an Impressionist work, Seurat composed numerous on-site studies before completing the final work in his studio. He used uniform short brushstrokes—a precursor to the dots that would eventually become his trademark—and sharply defined figures so that each element remains distinct.

Statue, from *Where Do We Come From? What Are We? Where Are We Going?* *detail; PAUL GAUGUIN (1848–1903); 1897; oil on canvas. Museum of Fine Arts, Boston.* The boldly colored blue statue is an odd amalgamation of the numerous artistic traditions that inspired Gauguin. Although the statue's features stem from Oceanic island cultures, the frozen figure appears almost classical in its position and expression.

At the Moulin Rouge
HENRI DE TOULOUSE-LAUTREC (1864–1901);
1892; oil on canvas; 48³/₈ x 55¹/₄ in.
(123 x 140.5 cm). The Art Institute of Chicago.
Instead of the gay, light-hearted life of Paris, Toulouse-
Lautrec portrayed the darker, seamier Parisian
world that he knew best. The influence of Degas
is obvious in the apparently arbitrary way the view
is cropped, as is the influence of Gauguin in the unreal-
istic, garish colors that enhance the sense of mystery.

The Scream
EDVARD MUNCH (1863–1944); 1893; tempera
and casein on cardboard; 36 x 29 in. (91.3 x 73.7 cm).
Nasjonalgalleriet (National Gallery), Oslo.
Caught in a private nightmare, the central figure lets
out a scream that seems to expand into the very atmos-
phere with violent red, blue, yellow, and green swirls
that make the terror all-encompassing. Munch has left
the cause of the horror to the imagination of the viewer.

developed in the Renaissance, Cézanne juxtaposed warm and cool colors so that some forms seemed to advance while others seemed to recede. To achieve his stated goal of making the work "into something solid and durable like the art of the museums," Cézanne worked with simplifying forms in nature to their very essence—solid geometric shapes, based on the cone, square, and sphere—an approach that would later influence the twentieth-century Cubists.

While Seurat and Cézanne advanced toward a more empirical study of light, color, and form,

The Card Players

PAUL CÉZANNE (1839–1906); c. 1890–95; oil on canvas;
18¾ x 22½ in. (47.5 x 57 cm). Musée du Louvre, Paris.
In his still-lifes, landscapes, and informal portraits, Cézanne employed
variations in color to create depth. The severe lines of the table and background
wall present an intriguing juxtaposition to the rounded forms of the men.

Rejecting the late nineteenth century world of science, industry, and materialism, Gauguin attempted to return to what he considered a more natural state, both in his life, by moving to the South Pacific, and in his work, which sought to show the conflicts and intersections between East and West, innocence and knowledge, primitive life and civilization. Retaining the bright colors of the Impressionists, he created flat, simplified shapes of color, sometimes intentionally unrealistic and outlined with heavy black lines, in addition to unexpected shapes, slanting angles, and diagonals that reduced the illusion of depth. The result was paintings that portrayed eternal truths rather than transient moments.

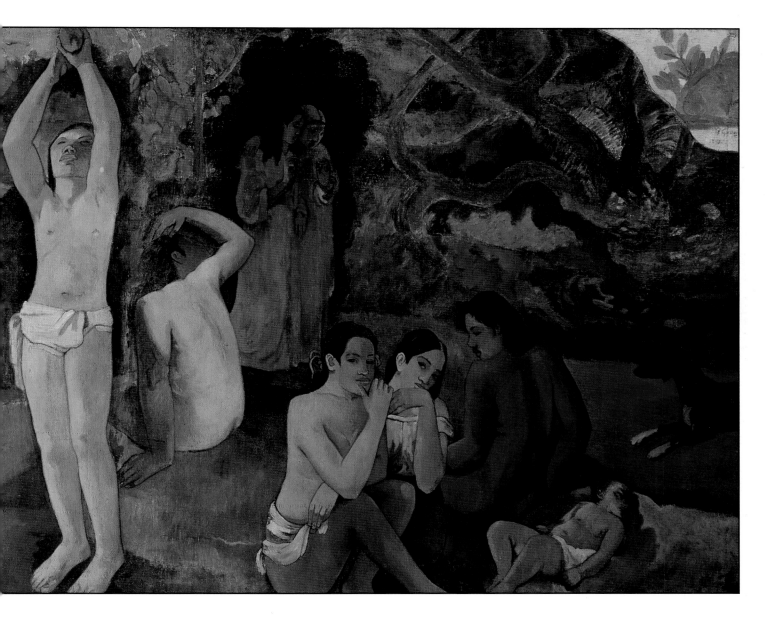

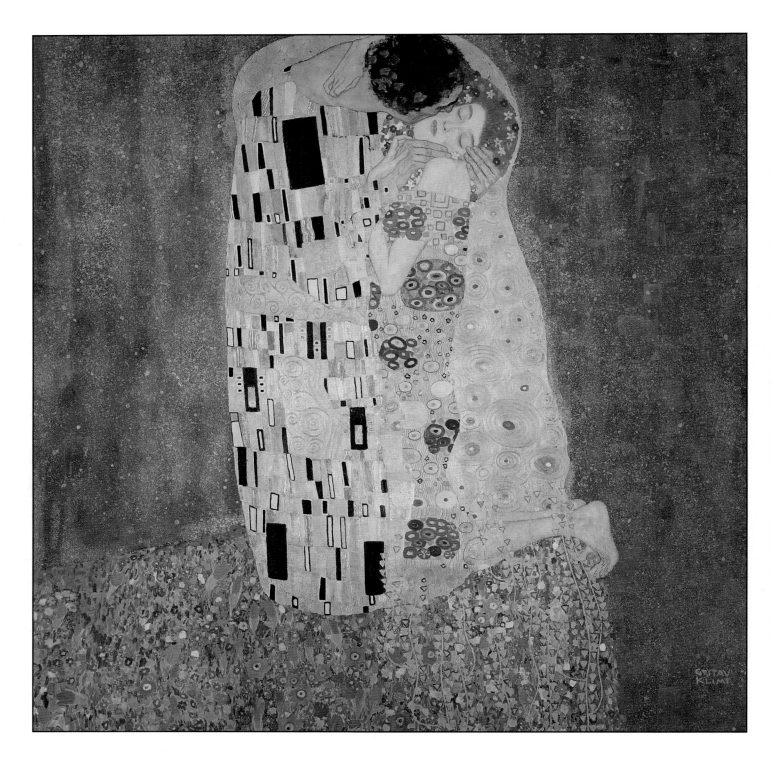

The Kiss

GUSTAVE KLIMT (1862–1918); 1907–8; oil on canvas;

5 ft. 10⅞ in. x 5 ft. 10⅞ in. (1.8 x 1.8 m). Osterreichische Galerie, Vienna.

Klimt was one of the most famous of the artists of the Secession movement, an outgrowth of Expressionism.
Many of his paintings are characterized by sensual and erotic images against a gold background. Geometric forms
are important—can the mosaiclike rectangles of the man's robe merge with the circles of the woman's clothing?

The Twentieth Century

As scientific, technological, and psychological advances proceeded at a breakneck speed, artists of the early twentieth century were confronted with a very different world from that of the previous century. The old questions about the merits of linear form versus color no longer seemed as relevant, and a new debate centered around the importance of objective forms as compared to inner truth. Until World War I, Paris continued as the center of art, although it was challenged by changes in Germany, Italy, and Russia. The innovations of the Post-Impressionists, especially those of Cézanne and Gauguin, continued to have a profound effect on art in the opening decades of the twentieth century.

Influenced by both painters, a group of radical artists emerged in France in 1905 and began to exhibit together. Critics and public scorned the bold colors and brushwork of the art, calling it the work of *fauves*, the French word for "wild beasts." Defiantly, the artists claimed the title for themselves. Although they ended up exhibiting together until only 1908, the premier artist of the group, Henri Matisse, stayed with the style.

The Fauves were part of a larger movement, that of Expressionism, whose goal was to evoke emotion in the viewer. In France, Matisse and the Fauves typified a concern with structure and formal composition, while the Expressionists in Germany were more interested in conveying intense human emotions.

The Joy of Life

Henri Matisse (1869–1954); 1906; oil on canvas; 5 ft. 8/3 in. x 7 ft. 10 in. (1.75 x 2.39 m). Barnes Foundation, Merion, Pennsylvania.

The most famous of the Fauves, Matisse simplified his compositions to include only the most basic and essential elements necessary to convey a mood. His figures, heavily outlined like those of Gauguin, are expressed in just a few quick lines against bright and unnatural colors.

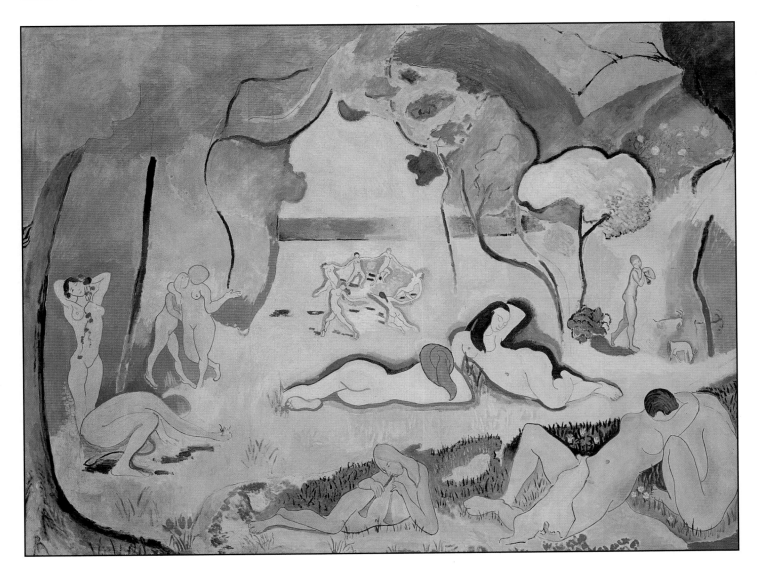

Parallel to Expressionism, another trend was developing, this one also owing much to Cézanne's use of bright color and geometric forms. In Paris, Pablo Picasso and Georges Braque worked together to formulate the concept of Cubism. Analytical Cubism, its first stage, held that a painting is the record of the artist's analysis of objects seen from various viewpoints and depicted simultaneously. Although revolutionary at the time, the principle is really not that far removed from the fractional representation of the ancient Egyptians: in both instances, one object is depicted from several viewpoints. For a few years, the two painters worked within a limited color range of muted browns, greens, and blues before expanding the concept in 1912. In Synthetic Cubism, the full range of colors was restored as well as a new attention to texture, which was enhanced by the addition of cut-out objects as collage elements.

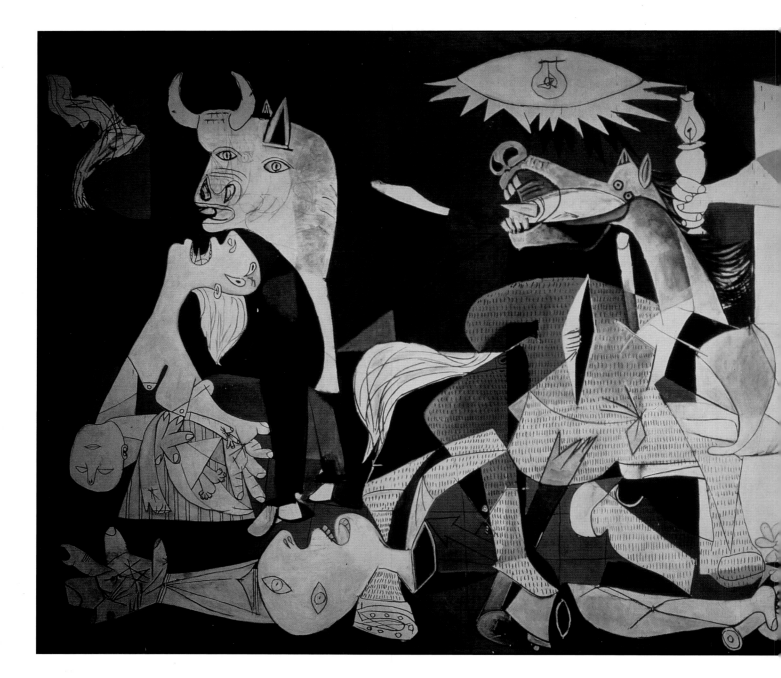

Cubism took off across the world, and variations on the theme were devised in countries as culturally disparate as Russia, where Kasimir Malevich painted his extreme *White on White*, consisting of a white square against a white background, and Holland, where Piet Mondrian painted compositions of vertical or horizontal—never diagonal—stripes, usually in red, blue, and yellow. Sculpture, too, was affected by this obsession with geometric forms and the medium thus became increasingly abstract and less realistic.

With the beginning of World War I, artists in Zurich and New York, both neutral cities at the time (the United States did not enter the war until 1917), sought to produce works that would convey their objection to the so-called reason and rational thought that had led to the war. Seeking to shock the middle-class establishment and illustrate the concept of the absurd, their works

Guernica

PABLO PICASSO (1881–1973); 1937; oil on canvas; 11 ft. 6 in. x 25 ft. 8 in. (3.5 x 7.8 m). Prado, Madrid.
Picasso combined elements from Cubism and Symbolism to express fully the horrors of the Spanish Civil War. In somber black, dark blue, white, and gray, fractionalized figures are captured in eternal anguish, alongside evocative symbolic elements such as the fallen soldier still grasping his broken sword.

came to be called Dada, a nonsense word that means nothing and so embodies the very spirit of the movement. Marcel Duchamp, by then in New York, was its best-known champion, exhibiting works such as a urinal, a bicycle wheel mounted on a kitchen stool, and a reproduction of the *Mona Lisa*, on which he had drawn a mustache and goatee.

Between the world wars, Surrealism came to be the dominant style, taking its cue from the same movement in literature and a manifesto issued in Paris in 1924 by the poet André Breton. Based on the theories of Sigmund Freud, Breton advocated the fusion of the "seemingly contradictory states, dream and reality, into a sort of absolute reality, of surreality. . . ." The concept struck a chord with numerous artists and the Surrealist exhibition in Paris in 1925 included such notables as Pablo Picasso, Max Ernst, and Joan Miró. The most famous of the Surrealists, Salvador Dalí and René Magritte, did not join the movement until later.

With the invasion of Paris in World War II, the city lost its position as the major artistic center, to be supplanted by New York, where many artists had emigrated to escape the Nazis.

The Dream

HENRI ROUSSEAU (1844–1910); 1910; oil on canvas;
6 ft. 8½ in. x 9 ft. 9½ in. (2 x 3 m). The Museum of Modern Art, New York.
A customs official with no art training, the middle-aged Rousseau embodied the spirit of Surrealism decades before its official conception. His bold, primitive images of the exotic and mysterious enraptured and inspired Picasso, Degas, Toulouse-Lautrec, and other notables.

Without the objectivity of time, it is impossible to say who will be considered the masters of today and tomorrow's art world. Could the ancient Egyptians have suspected that the beautiful bust of their elegant Queen Nefertiti would still be admired more than three thousand years later? Did Leonardo da Vinci even dare hope when he painted the *Mona Lisa* five hundred years ago that museum-goers would line up to see her enigmatic smile? When Gauguin escaped to the South Pacific, did he ever dream that the society he had turned his back on would find inspiration in his works for the better part of a century?

If history can serve as a lesson, future art lovers and artists will find new masterpieces in all the traditional places: museums, galleries, public spaces, places of worship, under the rubble of ruined buildings. We might even know now the names of some of these artists. But others we cannot begin to predict. They might be artists currently rejected as hacks or as uninspired, or they might be unknown men and women toiling silently and anonymously. Whoever they are, it is certain they will explore new frontiers, creating new masterpieces that most of us would never have been able to imagine.

The Persistence of Memory

SALVADOR DALÍ (1904–89); 1931; oil on canvas;
9½ x 13 in. (24 x 33 cm). The Museum of Modern Art, New York.
Like bizarre dreams, Dalí's paintings elicit an immediate response but elude real
understanding. In this popular painting, time stands still, captured in the images of
melting watches and an invading army of ants against a stark, three-dimensional landscape.

INDEX